Piero della Francesca

San Francesco, Arezzo

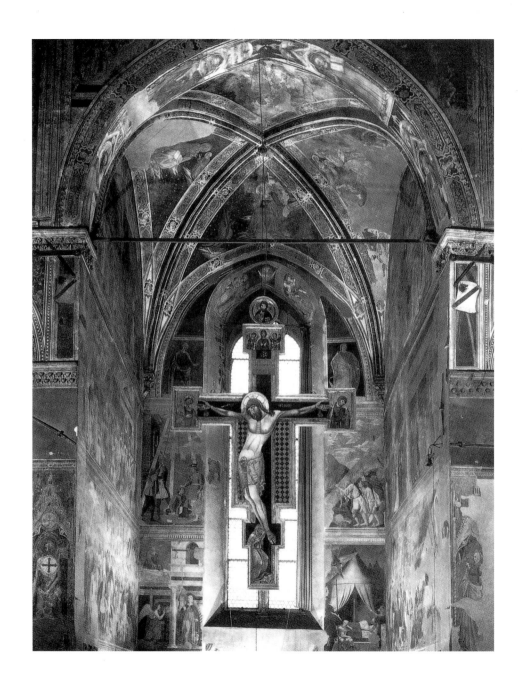

Piero della Francesca

San Francesco, Arezzo

Marilyn Aronberg Lavin

GEORGE BRAZILLER NEW YORK

Published in 1994 by George Braziller, Inc.
Texts copyright © 1994 George Braziller, Inc.
Illustrations (except where noted) © Scala/Art Resource, New York

For information, please address the publisher:
George Braziller, Inc.
60 Madison Avenue
New York, New York 10010

Library of Congress Cataloging-Publication-Data:

Lavin, Marilyn Aronberg.
 Piero della Francesca : San Francesco, Arezzo / Marilyn Aronberg Lavin.
 p. cm. — (The Great Fresco Cycles of the Renaissance)
 Includes bibliographical references.
 ISBN 0-8076-1317-7
 1. Piero, della Francesca, 1413?-1492—Criticism and interpretation. 2. Holy
Cross—Legends—Art. 3. Mural painting and decoration, Renaissance—Italy—Arezzo.
4. San Francesco (Church: Arezzo, Italy) I. Piero, della Francesca, 1413?-1492. II. Title.
III. Series.
 ND623.P548L38 1994 93-21669
 759.5—dc20 CIP

Frontispiece: The Legend of the True Cross cycle, chancel, Church of San Francesco,
 Arezzo. This view shows what was probably the original great wooden crucifix made
 for the chancel space and rehung in the 1980s. It is attributed to Margaritone
 d'Arezzo (ca. 1290). For further discussion of this crucifix, see p. 34.

Edited by Adrienne Baxter
Designed by Lundquist Design, New York
Printed by Arti Grafiche Motta, Arese, Italy

CONTENTS

The Legend of the True Cross Cycle: An Introduction 7

Chronologies 30

Plates and Commentaries 33

List of Figures 100

List of Plates 101

Selected Bibliography 102

Glossary of Fresco Terms 103

For Dora Jane Janson
and in memory of
H.W. Janson

Mentors and Models

The Legend of the True Cross Cycle
An Introduction

Of all the charismatic works by Piero della Francesca to have come down to us, two have received more attention than most. One is the quite small panel of the *Flagellation of Christ* (fig. 1); the other is the monumental cycle of frescoes representing the Legend of the True Cross in the Church of San Francesco, Arezzo (see pls. 1a–d), the subject of this monograph. These works hold unusual attraction for the twentieth-century viewer, in part because of their portentous stillness, and in part because of their mysterious lack of textual grounding. They seem to bear vital information just below the surface, yet there is no contemporary written evidence to elucidate their meaning. As a result, along with the admiration expressed for their appearance, speculation about their dates, function, and possible meanings abounds. Developing in a kind of pyramid of theories, conjecture has been added to educated guess, hypothesis added to assumption, each phase adding to the mantle of authority. By now, certain points that began as assumptions have been accepted almost as fact.

To be specific: The *Flagellation* was unknown before the end of the eighteenth century. Because of the astonishing emphasis on the three figures in the foreground, they were said to represent, not characters in the biblical story, but contemporary political personalities, namely the first three successive dukes of Urbino. By 1851 James Dennistoun (*History of the Dukes of Urbino*) reported

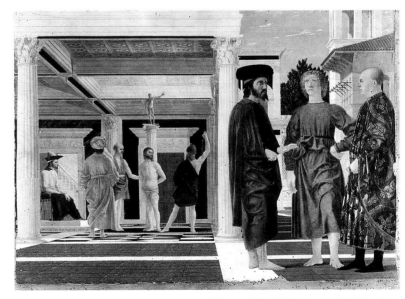

Fig. 1. Piero della Francesca, *Flagellation of Christ*, Galleria Nazionale delle Marche, Palazzo Ducale, Urbino.

that the youth in the center had been identified as Oddantonio da Montefeltro standing between the evil counselors who plotted his assassination in 1444. Later in the nineteenth century the bearded figure was declared an ambassador (Caterino Zeno) to the Turkish court; by the 1930s, Pilate, because of his costume, gained status as a reference to the emperor of Byzantium. On the basis of this clue, Kenneth Clark (1951) raised the iconography a notch and put it in the light of international politics (in spite of its patently private nature): the foreground figures signify the Eastern and Western churches under the threat of Turkish invasion, paralleled by the tribulations of Christ at the Flagellation. Since Clark's time almost every interpretation (and there have been more than twenty-five suggested identities for these figures) has taken a political component for granted. Only Gilbert (1968), recognizing certain anachronisms in such a reading, claimed there was no particular meaning to the figures, but without explaining why they should seem so important.

The same progression occurred in the interpretations of the great public fresco cycle in San Francesco. Apparently similar in style and details, the frescoes gradually became linked to the *Flagellation*. One of the closest points of contact is the fact that the bearded figure seated in the middle ground of the latter wears the same exotic headgear as a figure in one of the battle scenes in the former. The high-crowned hat with a long, pointed visor purportedly derives from that worn by the emperor John VIII Paleologus, and seen in Ferrara and Florence during the Council of Union in 1438-39; the

likeness was well-known from a contemporary medal by Pisanello (fig. 29). And because this ruler came to Italy looking for help in fighting the Turks, the *Victory of Constantine* (pl. 17) was taken as an allusion to the "Turkish Question," as it was called, and to the fall of Constantinople in 1453. These associations have gradually displaced all others, and from 1980 on, most Piero studies take the political significance of the cycle as its unquestioned point of departure (Ginzburg, 1981). As we shall see, any representation of the Legend of the True Cross, by its very nature, carries an undertone of crusade propaganda. However, a political undertone is one thing, while the religious purpose—that is, the first level of significance of a subject in a place of worship—is quite another.

In trying to redress this situation, the text that follows will treat the frescoes as visual documents of their time, seeking to learn directly from the paintings what we can about the cycle's location, function, historical context, and above all, its achievements as a work of art.

Background

Arezzo is today a town of about 100,000, some forty-eight miles southeast of Florence. Built as a Roman garrison named Arretium, it was converted to Christianity soon after the Constantinian decree of 316. Throughout the Middle Ages it fought fiercely for its independence, staving off repeated attacks by its Tuscan neighbors, particularly Florence. But characteristically, much of Arezzo's political

strife was internal, and because most of its energy was sapped by infighting, in 1385 it was conquered by the French and then sold to the city of Florence for 40,000 florins. From this time forth Arezzo was ruled by a Florentine administrator, and although rebellions followed over the next century and half, the smaller town remained a Florentine ward. Arezzo never got over this humiliation. Because of its pivotal position on the road from Tuscany to Umbria and the Marches, in the twentieth century, Arezzo became a commercial center and after World War II was one of the first towns in Italy to embrace communism. To the present day it retains its separatist character, boasting, for example, a commission of fine arts (*soprintendenza*) independent from that of Florence and the rest of Tuscany.

In the history of Arezzo's spirituality, one of the great events took place in 1211, when St. Francis of Assisi and a companion journeyed there. While still outside the gates, so the story goes, St. Francis was saddened to see devils exulting over the strife they were causing within the

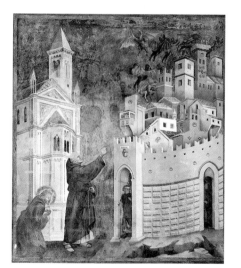

Fig. 2. Giotto? *Exorcism of the Demons from Arezzo*, San Francesco, Upper Church, Assisi.

walls. At his command his companion, Brother Silvester, exorcised the demons and brought peace to Arezzo (fig. 2). Immediately thereafter he founded a convent in the outskirts. In 1290, the Minorite brotherhood received permission to relocate inside the city (at its present location), where they were destined to play a larger civic role. In the same year Pope Nicholas IV conceded an indulgence of forty days to worshipers who came to the church on the Feast of the Annunciation (March 25); this important concession was renewed in 1298. The new church, designed by Giovanni da Pistoia in 1314, is a single-aisle hall church with three graduated flat apses. By 1322 some functions could be performed, and by 1338 it was fully operational. In 1374 the main apse burned; by 1397 the space, called the Cappella Maggiore, had been rebuilt and was ready to function again. Some time later, probably 1408, an Aretine family named Bacci arranged with the Franciscan friars to make the area a family burial ground, with the understanding that they would endow it with a suitable new decoration. In 1417 Baccio di Magio Bacci, paterfamilias, died and was duly buried near the chapel. All these arrangements, which are well documented, were part of normal procedure. It was not, however, until 1447 that the decoration project got underway. At this point the documentation grows dim. All we know is that Baccio's son Francesco and two nephews, Andrea and Agnolo, sold a jointly owned vineyard to raise cash to pay for the chapel's decoration. Who they hired and what they stipulated we can only surmise from circumstantial evidence.

Location

Because of dripping paint, it is usual for mural painters to work from the ceiling down to the floor, and so it was in the Cappella Maggiore at Arezzo. On the four webs of the groin vault are figures of the four evangelists attributed on the basis of style to the Florentine septuagenarian Bicci di Lorenzo. A long, horizontally disposed *Last Judgment* by the same hand stretches across the exterior of the triumphal arch, giving an eschatological framework to the Legend of the True Cross when viewed from the nave (see pl. 1a). We know that Bicci died in 1452, and that date is usually taken as Piero's starting point; a few scholars believe he might have started a bit earlier. There is no question that Piero also painted the walls from the top down, but whether down one wall and then another, or with scaffolding filling the whole apse, painting simultaneously on all three walls, moving down tier by tier, is a matter of conjecture. Two things are sure: He did not paint the scenes in chronological order and he worked out the narrative disposition long before he first climbed the scaffold.

From what is now known of commissions in general, signing a contract was the first step in a long process of planning and preparation. Such a large project would have involved protracted discussions among the friars, who were the de facto and ideological proprietors of the church; the donors—the Bacci—who would also have had a role in the iconographic agenda; and the artist, who would have proposed cogent ways to translate the desires of his backers into visual terms, adding his own contributions through artistic expertise.

For such a commission, financial arrangements were always complex and time-consuming: the raising of cash from property, goods transferred for down payments, partial payments, the purchase of materials, payment to assistants, and the final settlement. In several cases in Piero's career, we know that work on and payments for altarpieces went on for more than a decade. For the Arezzo commission, there are three documents of a subsidiary nature that locate the cycle to a particular time slot: (1) a payment for Piero's lodging when he was at work that was made to the monastery of Santa Lucia in Arezzo in 1456; (2) payments in the Vatican archive that place him in Rome between the spring of 1458 and the fall of 1459, during which period he was *not* in Arezzo; and (3) a contract for a processional banner in 1466 that refers to the frescoes in the past tense, meaning they were completed by this time. Thus it is possible, and probable, that the Arezzo frescoes, too, were in progress for more than a decade, from the early 1450s into the early 1460s. They show very little evidence of stylistic change, and certainly no trace of an early or immature style. The pouncing (see Glossary) visible throughout the cycle reveals that Piero prepared every figure as carefully as his own contemporary mathematical studies. Evidence of mistakes, *pentimenti*, or changes of plan is minimal, again indicating that the conception of the cycle, its narrative arrangement, and its intention must have been well in hand before brush was laid to wall.

Conceptual Planning

The fresco cycle covers all three walls of the rectangular chancel (15m x 7.7m x 7.5m). The side walls are divided by painted cornices into three superimposed tiers each 3.2 meters high, above a dado of elaborately painted panels imitating alternating colors of marble set in frames; the dado is about 2.5 meters high. The slightly pointed arch shape of the vaulting defines the top tiers, or lunettes, which Piero outlined with an original painted pattern of irises and palmettes. The two lower tiers are rectangles, outlined with painted moldings and dentils. Several episodes of the story are represented on each tier without internal framing. This arrangement is usually called "continuous narrative mode," that is, figures appear more than once at different narrative moments against a single, continuous background. The altar wall (in the fifteenth century the altar where the liturgy was performed would have been flush with the back wall of the apse, under the central window) has the same three tiers: the uppermost with isolated figures; the second and bottom with "monoscenic" images, that is, figures represented in a single moment in time. On all the tiers, Piero arranged the line of sight to place the spectator at ground level, looking head on. In other words, to have the proper viewing position, one would have to float magically up several meters three different times.

There is no gainsaying that, along with the physical distance, the arrangement causes difficulties in visibility; but it is important to remember that, given the idea of decorating this sort of vertical space with narratives, artists of the time chose many different approaches, none of which had much to do with the real viewer. For example, Fra Filippo Lippi's cycle in Prato (Lives of Sts. Steven and John the Baptist) starts on the bottom tier with an angle of vision that slants slightly upward; on the center tier the angle is steeper; and on the top tier the angle is very oblique, with dramatically tilted-up perspective. In the same decade Mantegna, in the Eremitani in Padua, chose a third alternative. His lower tier is seen at a sharp angle below, the central tier is seen head on, and the top tier is seen from above at an oblique angle. From these three contemporary variants, it becomes clear that there was no "correct" way of structuring the painted space; each artist opted for an effect that fit the ideas he was portraying. In Piero's cycle the head-on position relates the compositions to classical reliefs: multiple figures on a narrow stage-space, set before a background that implies depth but with limited spatial recession. Each tier is approached in the same way; each has an identifiable rationale; each requires the viewer in an ideal position. Piero's approach is thus, not unexpectedly, consistent, unified, and ideal.

Style

The spatial arrangement is matched by the figure style. Piero's greatest claim to fame is based perhaps on his finely constructed figures. His men and women are solidly balanced on the vertical plane, making contact with the earth with the heft and resilience of organic bone and flesh. At the same time, they ignore the deviations

and accidents of nature; their individual parts seem stabilized by the forces of geometry, and often one can actually see the stereometry in drawing beneath the painted structure of a form (pl. 23). Indeed, in Piero's treatises on *The Five Regular Bodies* and *Perspective for Painters* (Piero was a superior mathematician, one of the greatest of his age), his illustrations of the human figure, particularly the heads (fig. 33), reveal his obsession with Euclidian rules of measurement in an endless search for ideal form.

But even such a carefully calculated system cannot explain the inspirational effects of light and color that are also Piero's hallmark. In one of the most famous scenes in the cycle, we see light effects of startling brilliance: a night vision in which an angel flies down, breaking the darkness with the divine illumination of his message (pl. 15). In another scene of raging battle, colors vary from black, brown, and white horses to shining metal armor, leatherwork dyed blue and light green, jerkins and doublets of crimson and mauve under the gold and black banners of the opposing sides (pl. 24). Surface patterns, costumes, materials, shadows—all are pictorial effects as important to Piero as his forms. To achieve these results, he willingly mixed his painting technique, using not only the broad strokes of earth tones in *buon fresco* but also adding tightly painted details in tempera (pigment with animal glue), tempera *grassa* (pigment with egg yoke), and even oils from time to time. The perfection of his forms would be dry and meaningless without the chromatic beauty and balance of his light and color.

What is true of the conformation of Piero's figures is also true of their expression. He paints faces that are unbeautiful but strong. They vary between the delicate androgyny of country youth and coarse ethnicity; in psychological content between modest femininity and bold matriarchal power. Depth of expression is conveyed not by overt facial gesture, but by the suggestion of the inner movements of thought—the slight parting of lips, the concentration of a gaze, an anxious puffiness under the eyes, the variation between two matched eyes or nostrils—and above all by the barely perceptible difference between underdrawing and surface shape. By these means Piero conveys the intensity of figures' feelings. Underneath their timeless poses, one can always sense the regularity and control of human logic. Within their glances, one can always sense a preoccupation with human survival. In our own time of political unrest and physical threat more universally experienced than ever before in history, in this period of bursting visual and auditory assault with which we live on a twenty-four-hour basis, Piero's silent, stationary figures offer an alternative. By their form and content they represent thoughtfulness; they envision deep regard; they invite contemplation of worthy goals. They offer some assurance that there is a realm where human intelligence rules, where it is still worth aspiring to be. These are the qualities of style and content—abstraction is too simple a term—that make Piero della Francesca so dear to the twentieth-century sensibility. We shall see that these qualities are part and parcel of the Arezzo cycle's message, and that Piero used

them knowingly to transmit his ideas to the spectators of his time and across future centuries.

Iconography

The subject of Piero's cycle was chosen by his patrons. The Legend of the True Cross had special meaning in the religious teachings of the Franciscans, and by the mid-fifteenth century they had used it on several occasions to promulgate their religious agenda. St. Francis's "conversion," that is, the moment when he left the worldly life of a *cavaliere*, came after his vision of the Cross emblazoned on suits of amor. He realized then that he should follow the Cross rather than the crusade in which he was taking part. Henceforth, devotion to the Cross was one of his main preoccupations, and his veneration of the symbol of Christ's passion remained uppermost in his mind until his own death. In fact, according to the official account of his life by St. Bonaventura (1221–1274), he was in a retreat at Mount Alverna during the period of the great Cross feast (the Exaltation of the Cross, September 14) when he received in his own body the wound's of the Crucifixion, the stigmata. As a result, the story of the Cross—the miraculous origin of its wood, its role in the scheme of salvation and then in the history of the Christian church—became identified with the Franciscan order in its quest for the salvation of souls. There were also more topical reasons (to be discussed below) for choosing the subject for the frescoes.

The actual Legend of the True Cross is a compilation of a number of stories, both Near Eastern and European in origin, brought together for the first time about 1265 by Bishop Jacobus de Voragine in his compendium of the saints' lives known as *The Golden Legend*. This extraordinary book was written in Latin but very soon was translated into many vernacular languages and widely dispersed. Passages from "The Invention of the Holy Cross" (May 3) and "The Exaltation of the Holy Cross" (September 14) are generally considered to be the source for several fourteenth- and fifteenth-century cycles of the True Cross, including Piero's. These passages recount how

(The Invention of the Holy Cross)

a branch of the Tree of Knowledge was planted at Adam's death, and produced a tree so beautiful that, centuries later, King Solomon had it cut for use in his palace then under construction. Because of its magic properties, the plank of wood kept changing size and he had it removed and used underfoot as a bridge. Its value was revealed proleptically to the queen of Sheba who warned Solomon that the "king" who would hang on the wood would replace him. In desperation, Solomon had the wood buried in a deep pool. The water of the pool thereafter became famous for its healing qualities, and remained so for centuries. During Christ's life, the log floated to the surface of the water, and ultimately was used to fashion the cross. Following the Crucifixion, the cross disappeared, but the place of the sacrifice became sacred. On this account, the Emperor Hadrian had a temple to Venus built over the spot, so that when Christians came to venerate, they would unknowingly be worshiping a pagan god. Two hundred years later, Helena, the mother of Emperor

Constantine, traveled to Jerusalem for the purpose of locating the relic of the cross. After some investigation, she found all three crosses, and through a miracle, discerned which was the "True Cross." Later, she caused it to be returned to the people of Jerusalem. Meanwhile, Constantine, on the eve of battle with Maxentius, contender for the imperial throne, had miraculously been shown the cross as a sign of his impending victory. The full meaning of the symbol was unknown to him at that moment. After the battle, in which not one drop of Roman blood was spilled, he understood that the victory was Christ's and he decreed that Christianity was now the state religion. He raised a great basilica over the spot where his mother found the cross, and the relic thereafter became world famous for its significance and for its power to perform miracles. (The Exaltation of the Holy Cross)

Toward the end of the sixth century, the Sassanian king Chosroes, a powerful necromancer, became jealous of the relic's potency and wished to possess it. In fact, he stole the cross [612 A.D.] and set it up in his silver tower, where he pretended to be god and tried to rule the workings of the cosmos. Heraclius, the emperor of Byzantium, heard of this blasphemy and vowed to retrieve the cross. He vanquished the son of Chosroes in a single combat, had the father decapitated, and again returned the cross to the citizens of Jerusalem. In fact, he gave back only half the relic, taking the other half to Constantinople, where it became the palladium of the city.

So ends the legend.

As we have seen, the liturgical aspects of this legend are manifested in two feasts: one that celebrates St. Helena's finding and proofing of the Cross; the other, a much older feast that venerates this holiest of symbols to which the historical account of Heraclius was added in the early seventh century. In 1377 Pope Gregory XI elevated the feasts to the highest rank of dignity and importance (formerly called "double majors") and had a new Mass (or divine office) written for the Exaltation Feast. Any representation of this legend, by implication, therefore, refers also to its liturgical value.

Side by side with this liturgical meaning was the political one. The story had its greatest period of development during the time of the Crusades in the eleventh and twelfth centuries. The

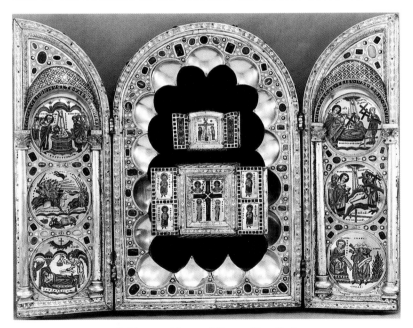

Fig. 3. *Stavelot Triptych*, Pierpont Morgan Library, New York.

account of profanation of the Holy Land by infidels and retrieval of the sacred relic made it an ideal paradigm of Crusade imagery and it was frequently used to manifest support for the campaigns. A superb example is the *Stavelot Triptych* (fig. 3), where Constantine and Helena episodes are paired in six gorgeous enamel rondels. Abbot Wibald of Stavelot (Belgium), the patron of this portable altar, was a promulgator of both the second and fourth Crusades. Following this period legends of the "knights of Christ," Constantine, Heraclius, Charlemagne, and Roland (Orlando), in both written and oral form and incorporating both the religious and political allusions, spread throughout Europe and entered into the general consciousness. By Piero's time all these elements—liturgical, political, and chivalric—were endemic to the story. In the middle of the fifteenth century, any representation of the subject could not but reflect the contemporary concerns of the papacy and the princes of Italy about ever-increasing danger from the Turks. It remains a question, however, whether there were specific factions in Arezzo who played a direct role in the counteroffensive.

In this respect it is important to note that the Franciscan order as a body had more than a general interest in the safety of the Holy Land. In the late thirteenth century St. Bonaventura, "The Seraphic Doctor," general of the order and official biographer of St. Francis, who helped convene a council of union between the Eastern and Western churches, declared a crusade against the Muslims. This action, for which he was raised to the rank of cardi-

nal, remained one of the order's major concerns. Under Robert of Anjou (ca. 1342), the Franciscans were granted various *custodia* in Nazareth and Jerusalem, at which point they became and would remain responsible for the physical protection of certain holy sites. The Franciscans also played a role in the 1430s Council of Florence. Although the Aretine Franciscans would certainly have been informed about the Turkish threat at the time of Piero's commission, there is no evidence that they had any direct connections with movements toward renewed crusades. As for the Bacci family, they were merchants who for generations had depended for their wealth on commercial connections with the Orient, importing spices and herbs. It is improbable that they would have contributed to an actual crusade that would have jeopardized the source of their own income.

We do not know if Piero himself took a political position. During his lifetime he held several civic positions in his hometown of Sansepolcro, but there is no indication of his political beliefs. Within the cycle, however, he did make certain contributions to which we will return after a discussion of the paintings themselves.

Narrative Disposition

One of the strangest aspects of Piero's cycle is the way it is arranged on the wall (fig. 4), with the narrative following what can only be described as a turbulent pattern. Starting on the top tier of the right wall, it reads first from right to left. Then, descending to the second tier, it reverses direction, reading now from left to right. Next it

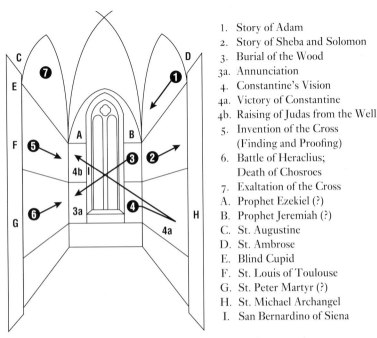

1. Story of Adam
2. Story of Sheba and Solomon
3. Burial of the Wood
3a. Annunciation
4. Constantine's Vision
4a. Victory of Constantine
4b. Raising of Judas from the Well
5. Invention of the Cross
 (Finding and Proofing)
6. Battle of Heraclius;
 Death of Chosroes
7. Exaltation of the Cross
A. Prophet Ezekiel (?)
B. Prophet Jeremiah (?)
C. St. Augustine
D. St. Ambrose
E. Blind Cupid
F. St. Louis of Toulouse
G. St. Peter Martyr (?)
H. St. Michael Archangel
I. San Bernardino of Siena

Fig. 4. Diagram of narratives, chancel, San Francesco, Arezzo.

jumps to the altar wall, second tier on the right, after which it descends diagonally to the lowest tier on the left side. It then moves left to right across the altar wall to the bottom tier of the right wall. From the right edge of this tier, it jumps back to the altar wall, second tier on the left. The next scene is found on the left end of the second tier on the left wall, where the story reads left to right. It descends to the bottom tier and again moves left to right. Finally, it rises to the top tier, the left lunette, and ends in a single unified, centralized composition.

Much has been written about this unusual arrangement, which at first seems so irrational and therefore puzzling in relation to Piero's rationalism; on this topic we will have more to say later on. Most important, however, were the observations that, in "rearranging" the narrative chronology, Piero created a new pattern, in the form of sets of paired compositions that relate across the space of the chapel. The lunettes match: they are the beginning and the end of the cycle, both focusing on the wood of the Cross. The second tiers match: both divide the space between landscape and architectural setting; both show the prescience of queens. The scenes on the second tier of the altar wall match: they both show secular figures in action, one lifting a man up from a well, the other forcing a log down into a pool. The scenes on the lowest altar wall tier match: they are both Annunciations, with the news brought by an angelic messenger. And the bottom tiers on the side walls match: they are both battle scenes, filled with horses and soldiers and waving flags. Many commentators on the cycle, semiologists and structuralists as well as art historians, have seen this pairing as part of Piero's modernity, recognizing in it another element of his tendency toward abstraction and lack of concern with traditional expression.

The problem with such interpretations is that they do not match what we know about fifteenth-century commissions. The artist would never have been allowed to submerge the religious content of the theme for purely artistic reasons, nor would he have thought of doing so, since the "art for art's sake" concept would not

be invented until the nineteenth century. What was part of fifteenth-century tradition, on the other hand, was the experience of rearranged narrative disposition. For one thing, popular street songs (*chansons*) and plays seen out-of-doors (*sacre rappresentazioni*), were habitually presented in nonlinear compositions. Since familiarity with the plots can be taken for granted, we may surmise that rearrangements were used to signal new messages, ones that were larger and more profound than could be expressed by the simple linear narrative. When we look at the history of ecclesiastical fresco painting in Italy, moreover, we find that not only was pairing scenes across the space a common practice, but rearrangement of the narrative line to expand meaning was also part of the artists' stock in trade. In fact, it can be shown that a number of basic patterns of disposition were used regularly from the fifth to the sixteenth century to reorganize narratives to expand their meaning (figs. 19a – 19c). What Piero did that was truly unusual was to rearrange his narrative more drastically than other artists by combining more of these patterns. And, in doing so, he created pairs that are more strictly balanced and symmetrical. At the same time, knowing the historical chronology of the story line, one remains aware of its turbulent reversals, as though the raucous sense of storytelling was just as important to Piero as was his stately declamation. Piero's overall composition, then, creates a combination that is entirely new: a story of crusading knights and ladies fair that speaks to the political situation of the time, and a philosophical abstraction that rises to an ideal level in which the fundamentals of the Christian faith are defined. How he achieved this goal, and what was the significance of doing so at this time, will be the subject of the rest of this discussion.

Innovations

By the time Piero worked out his cycle, there were three monumental representations of the True Cross story, in Florence, Volterra, and Empoli. The first to combine the feasts of the Invention of the Cross and the Exaltation of the Cross visually was Agnolo Gaddi, who painted the cycle between 1388 and 1393 in the chancel of the great Franciscan church of Santa Croce in Florence (figs. 5, 6–8, 12, 15, 17–19). This cycle combined many motifs already worked out by manuscript illuminators with astonishing inventions of its own. Gaddi arranged his cycle so that the scenes of the two liturgical feasts face each other on opposite walls, Helena on the right and Heraclius on the left. There is no reference to the Constantinian episodes. The resultant sequence of images immediately became the authoritative statement of the legend. The cycles by Cenni di Francesca di Ser

Fig. 5. Diagram, Santa Croce, chancel, Florence.

Cenno in Volterra (1410) and by Masolino in Empoli (1424), while introducing certain variations, essentially follow Gaddi's arrangement and choice of subjects. All the cycles, including Piero's, place the opening scenes of the story at the top of the right wall. In doing so, they follow an Early Christian protocol for fresco cycles, passed down from Old St. Peter's itself and still visible in the Renaissance. Referring to this ancient tradition gave authority and substance to the legend that was to follow.

The most significant aspect of Piero's cycle in relation to Gaddi's frescoes is the difference. The Santa Croce cycle is based on the liturgy of the two Cross feasts; it deals only with the episodes of St. Helena and those in which Heraclius appears; it contains no reference to Constantine (who is not a saint in the Western church). As we shall see, Piero changes this aspect of the subject matter, but he nevertheless pays homage to his great predecessor by alluding quite pointedly to some of Gaddi's compositions. In other instances he makes changes so fundamental that there emerges a wholly different point of view, which we shall now follow in some detail.

In the lunette on the right wall Gaddi introduces scenes of Adam and his family into his version of the story. In a continuous narrative he shows Adam's son Seth speaking to the archangel Michael above, then Seth planting a branch over Adam's dead body below (fig. 6). To this opening chapter, also in the right lunette (pl. 2), Piero adds an episode that is unique. In a pose recalling images of his own creation, old Adam reclines on the ground supported by the equally aged Eve. At nine hundred years of age, Adam is dying. As his offspring know nothing of suffering and death, he lifts his hand in declamation to explain these mysteries to them. Piero thus launches his cycle with a visual meditation on the solemn message that death is a necessary step toward salvation.

Moving from right to left, Piero's narrative next shows Seth speaking to the archangel, greatly reduced in size in the background, then returns to the frontal plane where Adam's funeral takes place. As Seth plants a branch of the Tree of Life over the diagonally placed body, Adam's sons and daughters mourn him in a variety of poses.

Fig. 6. Agnolo Gaddi, *Story of Adam*, Santa Croce, chancel, right wall lunette, Florence.

Behind this linear progression, a great tree rises up and spreads across the upper part of the lunette. Here is the true subject of the composition: the Tree of Life from a branch of which will grow the wood of the Cross. Although now seeming lifeless and black, we know from infrared photographs that the tree was originally covered with masses of green leaves. Thus decked in triumph, it was emblematic of a fundamental Christian tenet known as the "paradox of the Fortunate Fall." The notion, first defined by St. Ambrose in the fourth century, is recorded in the "Praeconium Paschale" sung on Holy Saturday. It refers to Original Sin as the *felix culpa*, the happy fault, acted out between Adam and Eve in the Garden of Eden. Because of Adam's sin, man will die. Yet, because life that ends in death makes salvation necessary, the sin is happy. Without it, the Savior's advent would not have taken place and man's destiny would have been diminished. It is the *felix culpa* that calls for the root of the Cross to be planted, and lets the scheme of salvation begin. With the unique scene to the right of the composition, Piero gives the story a logical beginning missing in all other cycles, and thus alerts the spectator to the fact that each parcel of his narrative will be part of a larger mosaic of significant Christian ideas.

Moving forward to the period of the biblical kings, the narrative now descends to the second tier and reverses direction, reading from left to right. The story of Sheba and Solomon is shown in two separate episodes: the queen of Sheba surrounded by her ladies, kneeling in veneration before a log of wood to the left, and the Meeting of Solomon and Sheba to the right.

In *The Golden Legend* and in Gaddi's Santa Croce cycle one of the points of the Sheba/Solomon episodes is the duping of the Old Testament king known for his wisdom. Solomon is at first irritated by a beautiful but unstable log of wood; after Sheba forecasts his downfall, he becomes frightened and has the log buried. Gaddi shows both of these events with relative relish, giving the workmen exaggerated poses and Solomon a ridiculous, forlorn air (fig. 7). When Piero takes up the episode he turns it completely around, elevating and aggrandizing it in several ways. First, he omits any reference to the deviant log. The wood now appears as a perfect geometric shape, already in use as a bridge in the center of the composition. Sheba, whose journey

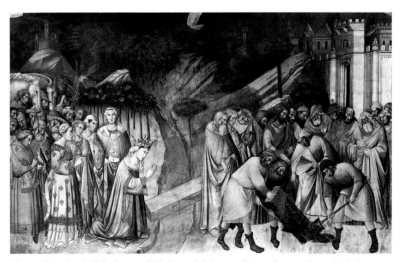

Fig. 7. Agnolo Gaddi, *Story of Sheba and Solomon*, Santa Croce, chancel, right wall, second tier, Florence.

from faraway lands is implied by the rolling landscape background, has fallen to her knees in adoration, her stunning companions transfixed by their own sudden revelation (pl. 5).

Second, Piero introduces a scene, long known to tradition but entirely new to the story of the Cross. No more the foolish king who tries in vain to change the course of history, Solomon is a grand monarch in regal robes of gold damask and the broad-brimmed hat of the Jewish potentate. He and Sheba are surrounded by their courts, and they greet each other with a solemn handclasp. Piero thus returns to the biblical source for Sheba's visit (1 Kings: 10, and 2 Chron.: 9), where she comes, not to humiliate Solomon, but to prove his wisdom and is convinced. The encounter took on great significance in Christian theology because Christ Himself interpreted it as the pagan world's recognition of His own divine wisdom. As the pair meets within a portico of mythological grandeur, the change of plot replaces Solomon's gullibility with handfasting, a sign of equality between monarchs. Moreover, by making Sheba bow lower than Solomon, Piero underscores the king's superior wisdom and, in this way, ensures Solomon's proper role as an ante-type of Christ.

The third part of this chapter, the *Burial of the Wood* (pl. 9b), appears on the second tier of the altar wall. There, it retains its horizontal relation to the Sheba/Solomon episodes but is as far away as possible from the figure of the noble king. In fact, aside from removing the usual courtly witnesses who appear in Gaddi's scene, Piero gives his version a change of mood that can be classified as comic relief. The action is carried out by three disheveled workmen, who labor together to upend a knotty plank into a threatening, red-rimmed pool. In their sweaty struggle the first shamelessly exposes his genitals as his socks fall down; boosting the plank with the aid of a strut, the second bites his lower lip. The third pushes forward and down with his bare hands; he wears a wreath of leaves and berries suggesting pagan drunkenness and lack of wit. In a cycle concerned with great biblical and historical personalities, these men stand out as lowbrow ruffians. However, the reference is ironic, demonstrating as it does the innocence of those who are truly ignorant. Equally important is the compositional thrust made by the wood from upper right to lower left. Its insistence solves the dispositional anomaly by guiding the eye to the chronologically subsequent scene, the *Annunciation*, placed diagonally below and on the opposite side of the window (pl. 12a).

But not only does the *Annunciation* surprise us by its position; its very presence is unexpected because, again, it is new to True Cross iconography. Agnolo Gaddi and his followers included two Passiontide scenes, the *Dredging of the Probatic Pool* (also called the *Raising of the Wood*) and the *Fabrication of the Cross* (fig. 8). Omitting both, Piero substitutes the more auspicious opening moment of the scheme of salvation. He justifies this replacement under three rubrics. The first is the indulgence mentioned above, the one reflecting the Franciscan order's particular devotion to the Virgin. On this account, it is possible that the friars actually requested the inclusion of the subject. The second rubric is the *Annunciation*'s

relation to the opening episode of the cycle: there Adam reveals the need for a savior; here Gabriel announces the savior's birth. As the angel utters the word "Ave," the palm frond he proffers acts as the key to paradise, unlocking the sin of Eve. With this same symbol Gabriel also forecasts Mary's own entry into paradise. He thus reveals her not only as the mother of God but also as co-redemptress. The third rubric, and perhaps the most important for the story of the True Cross, is Mary's relation to St. Helena, discussed further on.

Meanwhile, it should be noted that by placing the *Annunciation* in this particular field, on the left side of the altar, to be followed by the scene on the bottom tier to the right of the altar, Piero incorporated the monumental (and preexistent) crucifix hang-

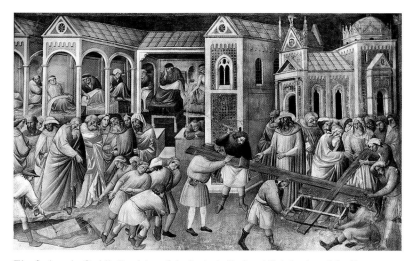

Fig. 8. Agnolo Gaddi, *Dredging of the Probatic Pool and Fabrication of the Cross*, Santa Croce, chancel, right wall, third tier, Florence.

ing above the altar in its "correct" chronological position in the narrative. Only by this arrangement is Christ's sacrifice emphasized as the nexus of the story—that is, following the last biblical scene and preceding the first scene of Christian history (see frontispiece).

Constantine's Vision on the bottom tier to the right of the window begins a two-section passage, the inclusion of which is in itself extraordinary (pl. 12b). Scenes of Constantine the Great had disappeared from representations of the story of the Cross after the period of the Crusades. Although *The Golden Legend* recounts more than one version of the Constantinian miracles, monumental Italian cycles presented only the exploits of Emperor Heraclius. At the same time, many of the motifs of Constantine in the Cross legend were transferred to the historical Heraclius, who became mythologized in Germany, as was Charlemagne in France, Germany, and later Italy. The transfers were effected in popular troubadour songs and poems, which tell of the stalwart knights and ladies fair, but where, in spite of the secular appeal, issues remained the search for Christian redemption and the protection of the faith. But as the Muslim Turks conquered more and more of the eastern Christian empire, the hero Constantine himself was once more called into action. One of the first times he reappeared in the visual arts was on the famous medals owned by the duke of Berry. Here, Constantine, probably symbolizing the king of France (Henry V), was paired with Heraclius, probably alluding to the current Byzantine emperor (Manuel Paleologus), who was campaigning for aid in France at the time (figs. 9a and 9b).

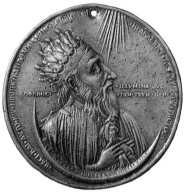

Fig. 9a. Pol de Limbourg?, *Medal of Constantine*, National Gallery of Art, Washington, D.C.

Fig. 9b. Pol de Limbourg?, *Medal of Heraclius*, National Gallery of Art, Washington, D.C.

Constantine was represented again with Heraclius in Spain (ca. 1410), on an altarpiece that otherwise followed Gaddi's arrangement of the story (fig. 10). Spain had long since expelled the Moors, and here the combination of Constantine and Heraclius refers to the two victories that bracketed the "reconquest," the battle at Alarcos in 1195 and the victory at Las Navas de Tolosa in 1212 (remembered in the feast of the Triumfo de la Santa Cruz, July 21). In the German Tyrol the parallel between Constantine and Heraclius was continued in the 1450s in a religious play that lasted two full days. In this decade the Turks actually conquered Constantinople (1453), and later at Negroponte, not so very far from southern Germany, Turkish troops were massing for an attack on Europe. It is no wonder that Pope Pius II convened the Council of Mantua (1459) to urge Italian princes to join forces in fending off the foe. As noted, the very commissioning of

the subject of the True Cross carried with it reference to current political events, and the introduction of the figure of Constantine in Piero's version doubtless reflected the consensus on the need for added Western defensive activity. But Piero did what had never been attempted before: he elevated the Constantinian scenes to a monumental scale and dramatized them in a new way. The Vision of Constantine had a long history in both the medieval East and West, but only in the minor arts. Such small-scale scenes show Constantine asleep on the eve of his battle with Maxentius, as a mystic visitor informs him of his coming victory under a cross. Piero not only aggrandizes the visionary moment but infuses it with light effects entirely without precedent in the history of art. In a blaze of light we see an angel streaking down from heaven. He holds in his extended hand a tiny golden cross (most of the gold has flaked off, and the cross is now seen best in infrared photographs). In a similar

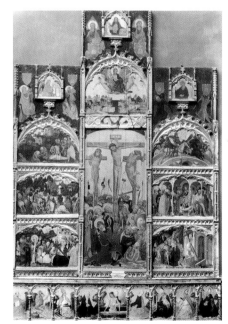

Fig. 10. Miguel Alcaniz, *Retablo Santa Cruz*, Museo Provincial del Bella Artes de San Carlos, Valencia.

configuration but different episode, Gaddi had painted Heraclius's vision with an angel carrying a huge cross (fig. 11). The power of Piero's emblem, on the contrary, is announced not as a physical presence but as a radiance that brings the scene to life. The fall of the light follows the angel's flight, from upper left diagonally downward, harmonizing with the descent of the Holy Spirit in the other *Annunciation* scene, and identifies the light again as divine illumination. The sleeping emperor will not understand this sign until after the battle, yet Piero gives him subtle knowledge even now (see the discussion with pl. 15).

The *Victory of Constantine* takes up the whole bottom tier of the right wall (pl. 17). It seems to spring to life from behind the wall

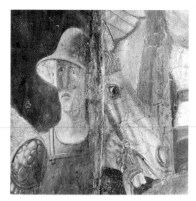

Fig. 12. Piero della Francesco, head of a guard from *Constantine's Vision* and horse's head from the *Victory of Constantine*, San Francesco, right corner, third tier, Arezzo.

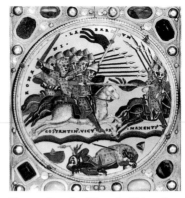

Fig. 13. Detail of *Stavelot Triptych* (see fig. 3).

at the inner corner, where the head of a guard and the head of a horse are mysteriously joined (fig. 12). Earlier small-scale representations of this episode were in typical Crusader form, as we have seen on the *Stavelot Triptych* (fig. 13): an equestrian charge with lowered lances and the enemy fleeing off toward the right. In Arezzo the speed of movement is reversed. Starting as a mass of foot soldiers and agitated riders, spears erect and banners waving, the army calms to an organized march as it arrives as the river. Shielded by his second in command, Constantine sits quietly on his white horse, holding a tiny cross as a talisman out before him. The vicious enemy Maxentius is routed by his own river trap and flees the charm with a barbarian accomplice at his side. There is no fighting, no conflict, only a quiet landscape. Aside from the inclusion of this scene, the

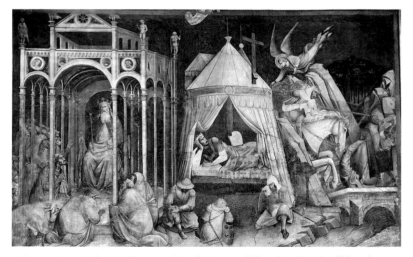

Fig. 11. Agnolo Gaddi, *Chosroes Adored; Dream of Heraclius; Battle of Heraclius*, Santa Croce, chancel, left wall, third tier, Florence.

novel element is depicting it not as a fight, but, for the first time in visual history, as a miracle. By representing it in this fashion, Piero gave the image particular Franciscan resonance. Eusebius of Cesarea, in his biography of Constantine, had likened the emperor in this victory at the water's edge to a new Moses, bringing the Romans to the promised land of Christianity. For similar reasons, St. Francis likened his order to a new Exodus and called himself a "new Moses." The parallel between Francis and Constantine as Christian heroes would not have been lost on the congregation at San Francesco.

When Constantine's mother, St. Helena, arrives in Jerusalem, she learns that only one man, a certain Judas, knows where the Cross is hidden. Because he refuses to reveal his secret, Helena has him imprisoned in a dry well. After seven days of torture Judas recants, is drawn out, and leads Helena to the Cross. The earlier illustrations of this scene, all on a small scale, emphasize the fact of incarceration, with Judas shown in the well. Giving it instead a prominent place on the altar wall, on the second tier to the left of the window, Piero focuses on the end of the episode, when Judas is extracted (pl. 9a). Moreover, in a clearly urban setting, he includes only secular characters: fancily dressed boys working a pulley; a well-dressed overseer with his striped *baton de command*; and Judas in contemporary clothes, awkwardly hoisting himself out of the well. For such details, Piero apparently relied not on legend illustrations, but on the unlikely source of Boccaccio's *Decamerone*. In the hilarious story of

Andreuccio da Perugia, when the "hero" goes to Naples to buy a horse, he falls into a dung heap, after which he is in dire need of a bath. Tomb robbers lead him to a well where there is usually a rope, pulley, and great bucket. Finding the bucket gone, they tie Andreuccio to the rope and lower him down. Guards of the watch, coming for water, are terrified when, instead of the bucket, Andreuccio appears (fig. 21). In Piero's version of the story, the young man stepping out of a well with a rope attached would surely have recalled this humorous situation to a fifteenth-century viewer. The scene thus joins its companion on the opposite side of the window as comic relief, portraying innocent ignorance. Both cases, however, have a serious side (see the commentary to pls. 10 and 11).

Fig. 14. Agnolo Gaddi, *Finding and Proofing of the Cross*, Santa Croce, chancel, right wall, fourth tier, Florence.

The next chapter in Piero's plot moves to the left wall, center tier, beginning on the extreme left, and represents the *Invention of the Cross* following some aspects of the tradition. Just as in the Gaddi cycle (fig. 14), a two-part composition puts the *Finding* on the left and the *Proofing* on the right. Piero distinguishes the two episodes by their settings: one is a landscape with a distant city view; the other is an urban setting with a deep view into the city. The architectural setting follows a version of the legend in which, after a temple on this site is destroyed, a new basilica is erected. The sumptuous façade behind the figures, which may refer to this future building, is certainly represented in a "future" style—that is, the suave classicism that would soon spread throughout Italy.

In the legend, at the moment the Cross is proofed, the devil is exorcised and heard to "shout and cry out." This narrative detail,

Fig. 15. Michele di Matteo, detail, *St. Helena Altarpiece*, predella, Accademia, Venice.

represented by Michele di Matteo in the predella of his *St. Helena Altarpiece* (fig. 15), leads us to an understanding of one of the other new elements in the composition: one of the grandest cityscapes in Renaissance art, a view of Arezzo

nestling in the saddle of the Tuscan hills behind the *Finding* scene (pl. 21). Besides giving the town the status of a "new Jerusalem" (a common conceit in the fifteenth century), the image more pointedly alludes to the important miracle St. Francis performed at Arezzo when he exorcised the demons (fig. 2), which, like the devil in Jerusalem, fled "shouting and crying out."

The same allusion to the vanquishing of the devil is the final element that binds the scene of the *Annunciation* into the cycle. St. Ambrose, in 395, was the first to report Helena's finding of the Cross. He describes the moment when she draws near the relic's burial place, and quotes her as she speaks directly to the devil: "'I see what you did, O Devil, in order that the sword by which you were destroyed might be walled up. . . .Why did you labor unless that you may be vanquished a second time? As Mary bore the Lord, I shall search for His Cross.' As Christ had visited a woman in Mary, so the spirit visited a woman in Helena. Mary was visited to liberate Eve; Helena was visited that Emperors might be redeemed." Ambrose thus demonstrates the necessary links that destroy the devil, tie Mary to Eve, and bond Helena to Mary.

In his cycle of the True Cross, Agnolo Gaddi included depictions of St. Helena returning the Cross to Jerusalem (fig. 16) and King Chosroes stealing the Cross (fig. 17) and declaring himself God. Piero omits both the theft and the blasphemy and proceeds directly to the remedy: the military victory won by Emperor Heraclius (pl. 24). Rather than representing the son of Chosroes and Heraclius in hand-

Fig. 16. Agnolo Gaddi, *St. Helena Brings the Cross to Jerusalem*, Santa Croce, chancel, left wall lunette, Florence.

to-hand combat, clashing on a bridge as in the story, Piero fills the lower tier of the left wall with the clangorous melee of a mass conflict. Although similar in theme, nothing could be farther in spirit from the calm dignity of the *Victory of Constantine* on the opposite wall. The scene is, for all of Piero's statuesque impassiveness, vicious and bloody. A similarity to Gothic manuscript chronicles (fig. 34) is amplified by references to late antique battle sarcophagi and specific Roman monuments (fig. 35), which "authenticate" the scene and place it squarely in the official imperial realm in the early centuries of Christendom.

The final scene of the cycle, the *Exaltation of the Cross* (pl. 29), skips up to the lunette at the top of the left wall. Here the entire field is unified in a single unit of time, although the story itself has two distinct parts. After his victory the Emperor Heraclius attempts to enter Jerusalem in triumph, mounted and in full regalia. He is blocked by an angel, who has walled up the city gate and who admonishes him for his pride. Heraclius thereafter returns as a penitent; the gate miraculously opens, and he is allowed to return the Cross to its rightful place.

Both episodes are seen in Gaddi's cycle, Heraclius on his horse stopped at the gate and Heraclius walking with the Cross (fig. 18). Described in a breviary reading for the Feast of the Exaltation of the Cross (September 14), these events were often illustrated in liturgical manuscripts. Piero's version, by contrast, shows only one moment. Heraclius, having removed his ceremonial clothes, walks on the ground carrying a huge Cross above his head (this figure is badly damaged). Unlike other renderings, where a close-up view of the Jerusalem gate is a major element, Piero shows no gate, setting his scene far outside the city. In an almost empty landscape Heraclius confronts a group of Jersualemites who have come to meet him. The innovation here is one of Piero's most ingenious. In classical Rome, when the emperor approached a town, the citizens paid him homage by coming out to greet him. The farther they traveled outside their town, the greater the respect they showed the emperor. By aggrandizing and isolating Heraclius's entry, removing

26

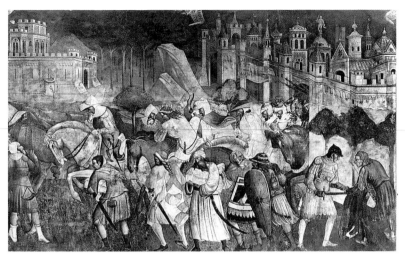

Fig. 17. Agnolo Gaddi, *Chosroes Steals the Cross*, Santa Croce, chancel, left wall, second tier, Florence.

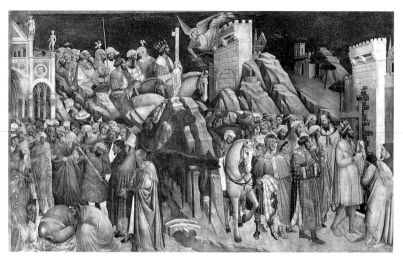

Fig. 18. Agnolo Gaddi, *Chosroes Beheaded; Heraclius Stopped by an Angel; Exaltation of the Cross*, Santa Croce, chancel, left wall, fourth tier, Florence.

it from town, Piero creates an *adventus* scene in which respect for the emperor is transformed into adoration for the Cross. One last touch enriches the Franciscan meaning of the cycle. By focusing on the emperor of Holy Rome, simply dressed and barefoot, Piero clearly makes Heraclius's penitential act into a prefiguration of discalced poverty, chief among Franciscan virtues.

Significance

We have now followed the narrative chronology through all its surprisingly picaresque meanders. What has not been said is that this narrative wondering was a conscious choice on Piero's part, and he achieved it by combining several standard fresco patterns developed by muralists over the centuries. Starting the narrative on the right in reference to early Christian protocol was only the first step. The two top right-hand tiers, reading right to left in the lunette and then left to right below, form a boustrophedon (fig. 19a), a pattern frequently used to express movement over time and space. The crossing diagonals on the altar wall, moving from upper right to lower left and then lower right to upper left, form a cat's cradle (fig. 19b), a pattern often used to emphasize the relationship between disparate subjects. The plot, in general moving down the right wall and up the left, follows the up-down down-up pattern (fig. 19c) frequently used to achieve a celestial position for appropriately sacred subjects. Further, the rearrangement of chronology creates a new order of matching pairs

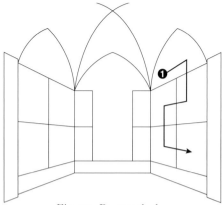

Fig. 19a. Boustrophedon

Fig. 19c. Up-down Down-up

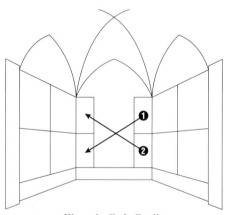

Fig. 19b. Cat's Cradle

from wall to wall across the space that, as we have seen, is similarly based on traditional mural art. Thus, by shifting his plot about—or to put it more positively, in his planning of the narrative order—Piero broke no rules. As was usual with him, he made something new

out of the old ones. The fact is we are meant to see both the irregularity of the narrative order and the symmetrical pairing of the tiers, and to feel the tension between them, because it underscores the final point of the cycle. In Agnolo Gaddi's cycle the organization of episodes reverses reading direction on every tier. In his case, chivalric narrative order, plus details of dashing knights in Gothic armor, leave no doubt as to the cycle's French troubadour character. When Gaddi painted his cycle in the late 1380s, the French had just entered Florence, to the citizenry's great joy; the donors of the cycle (the Alberti family) gave a huge celebration to welcome them. In this light, the disposition can be interpreted as having political meaning and the cycle seen as reflecting the Florentines' pro-French stance.

For his part, Piero leads us step by step to understand the particular meaning of the Cross legend in this particular locale. He too

refs to the *chanson* tradition but stanches the Franco-Florentine allusions by introducing the scenes of Constantine. As we have noted, the Emperor Constantine played something of a role in Arentine history. According to many civic chronicles, the medieval city counted itself uniquely blessed for having been converted to Christianity under his reign. Indeed, part of the city's self-image took shape from the fact that St. Donatus, the first bishop of Arezzo, was nominated by Pope Silvester, who in turn was appointed by Constantine. It is significant that Piero's fresco literally brings Constantine to Arezzo by placing his victory not at the Milvian Bridge, but at a tranquil spot on the Tuscan Tiber, with country houses (*case coloniche*) on its banks and ducks floating on its surface (pl. 19). Next, he identifies the antique emperor with what he knew to be an image of a "modern" heir to the imperial throne, namely John VIII Paleologus. And although the mission of that monarch had failed, twenty years later his image remained as a symbol of the long-standing Franciscan hope for reunification of the Eastern and Western churches and the defence of the faith against infidels. Even without evidence connecting the Franciscan friary at Arezzo to the call for a new crusade (under Pope Pius II at the Council of Mantua, 1459), Piero's imagery forms a bridge between the order's historic commitment to the unification/crusade cause begun in the late thirteenth century by Bonaventura and the current situation with the Turks. It was the same Bonaventura (at this time being promulgated for sainthood) who, in a sermon on the order's founder (No. 4), identified St. Francis directly with Constantine:

God revealed the sign of the cross . . . to two members of Christ's mystical body: to Emperor Constantine I and to St. Francis. . . . As he chose to imprint the sign of victory on Constantine, so he chose to imprint the sign of penance on St. Francis.

It is in the light of the reference to Arezzo's classical past, however, that the exaggerated symmetry of the thematic pairs takes on an almost patriotic air. For symmetry is but one of a series of classicizing elements that characterize the cycle. In moving away from anecdote toward greater iconographic cohesion, the scenes seem to follow Horace's definition of the epic mode: they are conceived with gravity, dignity, and harmonious decorum; they show variety without clutter; they blend seriousness with humor and without disgrace. We might say that Piero bent the erratic serial fable of popular culture into a heroic myth. What he displayed with all the grandeur of the *Iliad* or the *Aenead* were the founding facts of early Christendom: preparation for the messiah in patriarchal times, official conversion of the pagans, establishment of the cult of relics, suppression of heresy, and the liberation and protection of the Holy Land. By placing the moral strength of classical theory at the service of Christian institutions, he elevated his subject in both content and form, and transformed the Legend of the True Cross into a foundation myth of the Christian state. Through it he showed how the perpetual ministrations of the Franciscan order lead man to salvation, and he gave the people of Arezzo a fresco cycle that was both timely and timeless.

Piero della Francesca Chronology

1413 Some time after this date, Benedetto di Piero Benedetto Franceschi marries his second wife, Romana di Renzo di Carlo di Monterchi, and Piero is born.

1439 7 Sept., at Hospital of Santa Maria Nuova, Florence, Piero "sta chollui" (Domenico Veneziano).

1442 Piero is "consiglieri popolari" in the "Consiglio de Popolo" in Sansepolcro; to hold this post, a citizen had to be 20 years old.

1443 11 Feb., in Sansepolcro, Piero signs contract with Confraternità della Misericordia for altarpiece to be finished in 3 years.

1450 Signs *St. Jerome*, in Venice.

1451 Signs Malatesta fresco in Rimini.

1452 Bicci di Lorenzo dies; commission for San Francesco in Arezzo left open.

1454 Confraternity presses Piero to finish *Misericordia Altarpiece*; 4 Oct., contract signed for *Augustinian Altarpiece*.

1458–59 Piero in Rome.

1459 6 Nov., death of mother.

1460 Fresco of St. Louis of Toulouse in Sansepolcro signed.

1462 Payment on account, for *Misericordia Altarpiece*.

1464 20 Feb., death of father.

1466 Processional banner commission by Confraternity of the Annunciation.

1467 Work on Annunciation standard; holds public offices in Sansepolcro.

1468 In Bastia (outside Borgo, because of plague in city), completes banner for Annunciation society.

1469 Documented in Urbino consulting with Confraternity of Corpus Domini; payment toward *St. Augustine Altarpiece*.

1471 23 Feb., pays taxes in Borgo.

1473 Final payment, perhaps for *St. Augustine Altarpiece*.

1474 12 Apr., final payment for a lost painting in the Chapel of the Madonna, in the Badia in Borgo, perhaps started the year before.

1477 1 July, Begins service on the "Consiglio del Popolo" for 4 months.

1478 Paints fresco of the Madonna in chapel of Confraternità della Misericordia.

1480 Payment for repair of the wall "dove Piero aveva depinto la Resurretione."

1480–82 "Capo dei Priori" of the Confraternità di San Bartolomeo.

1482 22 Apr., rents living quarters with use of garden and well in Rimini.

1487 5 July, writes will; to be buried in the family tomb in the Badia; leaves money to Confraternity of "Corpuo de Cristo," Madonna della Badia, Madonna de la Reghia, and the rest, half to brother Antonio and half to heirs of brother Marco.

1492 12 Oct., dies (tomb with family arms, excavated in 1956, finds him to have been 180 cms tall)

Historical Chronology

1414–18 Council of Constance, seeking end of split in papal authority.

1438–39 Council of Union between Byzantine and Western churches, started in Ferrara, transferred to Florence.

1440 29 June, Battle of Anghiari, victory of Florentines over Milanese.

1442 Alphonse V of Aragon takes over throne of Naples.

ca. 1445 Carlo Marsuppini succeeds Leonardo Bruni as chancellor of Florence.

1450 Death of Lionello d'Este of Ferrara; succeeded by Borso.

1451 War of Florence allied with Milan and Genoa against Venice.

1452 Frederic III crowned Holy Roman Emperor in Rome.

1453 Fall of Constantinople.

1454 Peace of Lodi among Florence, Milan, and Venice caused by Turkish threat.

1458 Aeneas Silvius Piccolomini crowned Pope Pius II.

1459 Unsuccessful Council of Mantua calling for a crusade against the Turks.

1461	Piero de' Medici Gonfalonier della Justizia.
1464	Death of Cosimo de' Medici; declared Pater Patriae.
1468	Death of Sigismondo Pandolfo Malatesta.
1469	Lorenzo de' Medici becomes ruler of Florence.
1471	Borso d'Este created duke of Ferrara; Sixtus IV elected.
1474	Marsilio Ficino finishes *Theologica Platonica*.
1478	Pazzi conspiracy; Giuliano de' Medici assassinated.
1479	Venice defeated by Turks in 16-year war.
1483	Sixtus IV dedicates Sistine Chapel, Rome.
1486	Pico della Mirandola writes *Oration on the Dignity of Man*.
1492	Lorenzo de' Medici dies; Columbus discovers America.

Art Historical Chronology

ca. 1416	*St. George*, by Donatello, Orsanmichele, Florence.
1438	Choir loft for Cathedral of Florence completed by Donatello.
1444	Construction started on Palazzo Medici, Florence, by Michelozzo.
1450	Transformation of San Francesco in Rimini by Alberti begun.
1451–57	Mantegna paints Ovetari Chapel frescoes in Padua.
1452-64	Fra Filippo Lippi paints frescoes in Prato Cathedral.
1459-61	Benozzo Gozzoli paints frescoes in Palazzo Medici chapel, Florence.
1460-64	Chapel of the Cardinal of Portugal, San Miniato al Monte, Florence.
1462	Buildings at Pienza for Pius II begun by Rossellino.
1465	Paolo Uccello begins *Profanation of Host*, predella, Urbino.
1468	Laurana appointed chief architect at Urbino.
1472	Leonardo da Vinci's name entered in *Red Book of Painters*.
1475	Pollaiuolo's *St. Sebastian Altarpiece*.

ca. 1476	Botticelli's *Primavera*.
1481	Frescoes in Sistine Chapel, Rome, begun.
ca. 1481	Colleoni monument for Venice begun by Verrocchio.
1483	*Portinari Altarpiece* arrives in Florence.
1487–1502	Filippino Lippi paints frescoes in Strozzi Chapel, Santa Maria Novella, Florence.
1492	Michelangelo's *Battle of Lapiths and Centaurs*.
1495	Leonardo starts *Last Supper* in Milan.

Themes in the Legend of the True Cross

Story of the Fall of Man and the Planting of the Tree

Solomon's Disposal of the Wood

Fabrication of the Cross

Constantine's Vision before Battle

Constantine's Victory with Divine Help

Helen's Journey to Jerusalem; Debate with the Jews

Interrogation of Judas Concerning Relic(s)

Torture of Judas

Capitulation of Judas

Digging for the Cross

Discovery of Relic(s)

Helen's Proofing of Relic(s)
 raising of dead boy
 exorcism of devil

Theft of Relic by Chosroes

Chosroes's Heresy

Heraclius's Journey to Jerusalem

Heraclius's Battle with Pagans

Relic(s) Retrieved

Execution of Chosroes

Exaltation of the Cross

Relic(s) Transported
 to Jerusalem
 to Constantinople

Plates and Commentaries

In reproducing the individual frescoes and all of the details from The Legend of the True Cross cycle, we have preserved a sense of their orientation within the chancel, so that those on the right side are reproduced on a right-hand page in this volume, and those on the left are reproduced on a left-hand page here.

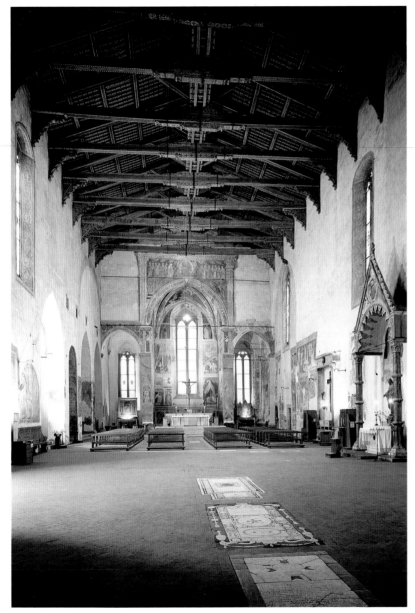

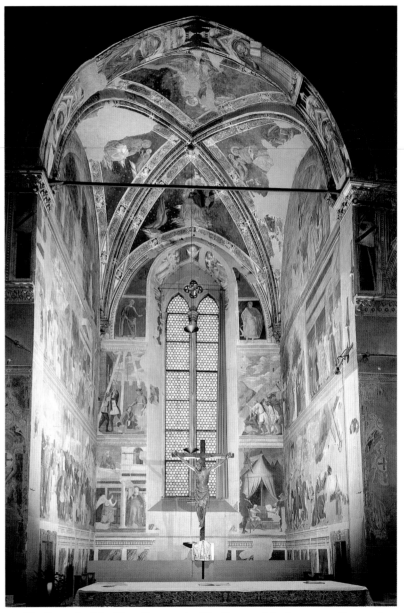

1a. Interior, The Church of San Francesco, Arezzo. Note the *Last Judgment* by Bicci di Lorenzo on the exterior of the triumphal arch framing the chancel.

1b. The Legend of the True Cross cycle. The figures of the four evangelists on the four webs of the groin vault are attributed on the basis of style to Bicci di Lorenzo.

1 a–d. Chancel of the Church of San Francesco

Over the centuries Piero della Francesca's frescoes did not remain famous. By the time an English traveler noticed them with fascination in the early nineteenth century, there was no idea of authorship; even their subject matter had been forgotten. Soon, however, their fame increased, and in the 1870s the director of the Ecole des Beaux-Arts had full-size copies made of two of the tiers (the *Invention of the Cross* and the *Battle of Heraclius; Death of Chosroes*) and had them shipped to Paris, where they could be seen by artists and critics alike. The frescoes had already suffered major damage, with areas where the walls were blank. Owing to excess humidity and salts inside the wall, their condition has continued to deteriorate, and despite heroic efforts in restoration and cleaning (still in progress), the colors are now greatly reduced and faded. The reproductions in this book are taken from transparencies made in the 1970s, before the ultimate phases of color loss had begun. What was probably the original great wooden crucifix made for the chancel space was rehung in the 1980s; it is attributed to Margaritone d'Arezzo (ca. 1290) and shows, at the bottom of the cross in a place where St. Mary Magdalene usually appears, a small figure of St. Francis kissing the bloodied feet of Christ (see frontispiece). Piero took care to incorporate the image of St. Francis's adoration of Christ's sacrifice into the narrative of his cycle.

The same color transparencies have been used for a recently created computer program designed to aid the study of the frescoes. A digitized reproduction of the chapel with its architecture and paintings in full color has been constructed in a Silicon Graphics VGX workstation. The special character of this electronic tool is that it can redraw the images at a rate comparable to that of human vision (about sixty times per second). It thereby produces an illusion of moving through space. The effect is so realistic it has been named "real time movement." The advantage to the observer is not only that the frescoes can be seen on the computer screen from any angle (some not even dreamed of by Piero), but also that the context, that is, the scenes to the sides, above or below, or those around a corner from the one being focused on, remains in peripheral vision. Using the traditional "mouse" or a new instrument called a "space ball," the viewer can move the line of sight in any direction, as the perspective automatically adjusts. The new tool will doubtless influence methods of analysis of works of art, both general views and details, and perhaps ultimately altogether replace slides and still photographs for this purpose (see Bibliography).

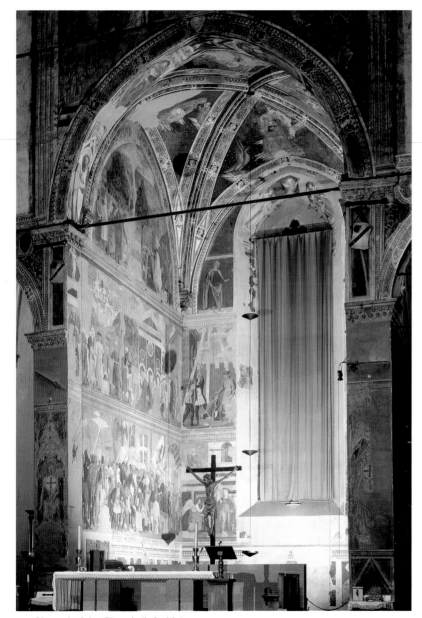

1c. Chancel of the Church (left side)

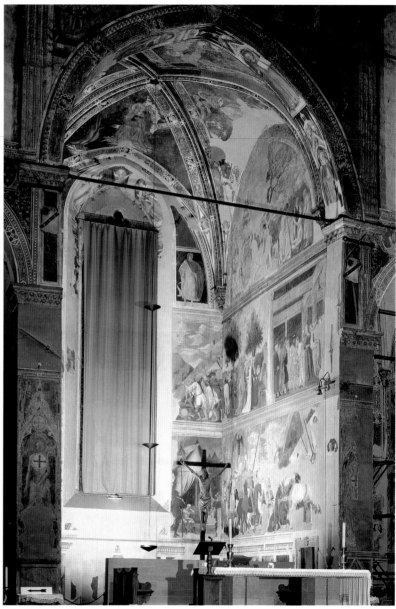

1d. Chancel of the Church (right side)

2. Story of Adam

In the first tier of the cycle, Piero follows the principles of continuous narrative—that is, he arranges three different episodes against a single, unified background. As we have noted, they read rather unexpectedly from right to left. In the opening scene of "Adam's Soliloquy on Death," Seth is told to return to the Garden of Eden to ask the archangel Michael for the "oil of mercy" that will end the old man's punishment. Piero retires the scene to the background, slightly to the left of the opening scene, where a second figure of Seth and the winged angel appear on a very much smaller scale. Their diminished size shows how far Seth has journeyed to the garden and removes the episode to a different time. Even though carried out in a relatively sketchy style, and at such a distance, one can see Michael's stern glance, indicating that Seth's mission has failed. When he reappears for the third time in the foreground, Adam is dead and the funeral is in progress. Seth has brought back only a promise and a cutting from the tree, which he patiently plants over Adam's diagonally placed body. The many other offspring act out unaccustomed feelings of mourning; one figure flings wide her arms and shrieks her broad lament. The variety of costumes in which the multitude is dressed—animal skins, togas, and robes—represent societal changes that took place during the nine hundred years their father lived.

All this exposition is clear when you know the story; if not, the narrative flow is less than obvious, for Piero has lined up most of the figures along the frontal plane and made them all almost the same height. The massing of forms makes it difficult to know their actual number; it is almost impossible to account for all the legs and feet in relation to the torsos that are visible. This technique achieves the effect of a great crowd (Adam and Eve had thirty sons and thirty daughters) while not overfilling the available space. In fact, the foreground alignment of isocephalic figures has the clarity of a classical sarcophagus.

Above the figures space does not recede, but rather suggests the almost tropical lushness of the Paradise Lost. At the same time, the arrangement takes advantage of the lunette's shape to frame the great tree that dominates the composition. When Adam and Eve sinned under the tree, it was said to have blackened and withered away. Much of the painted tree is destroyed, and what remains does look black and bare. Originally, however, it was covered with brightly colored leaves and therefore reflected the rest of the story: when the archangel Michael promised man's salvation at a future date, the tree regenerated and burst into bloom. Piero's image is thus a message of joy: the great tree, full of promise, rising over the melancholy of death, looking forward to the exaltation that will come at the end of the cycle.

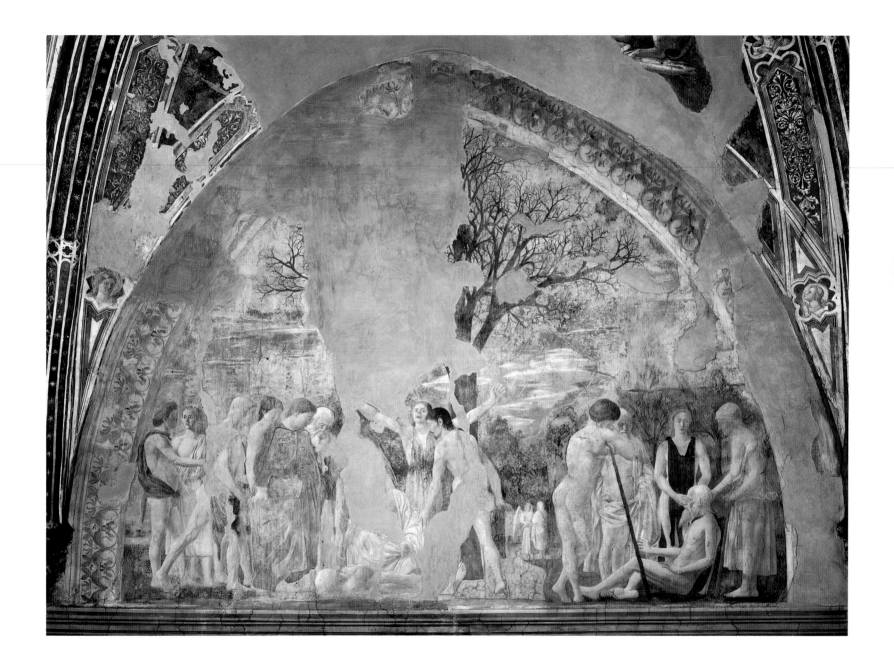

3. Death of Adam
detail of the Story of Adam

In the right corner of the right lunette, the decrepit old man that Adam has become reclines on the ground, one leg extended, one hand raised in declamation. He is braced from behind by the former temptress Eve, now an old woman with flaccid breasts and flattened feet, supported by a cane. Three of their sons stand nearby and listen in pensive silence. Until this moment, Adam alone among the family knew the meaning of death. He now shares his knowledge with them. Each of the three listeners shows Piero's interest in different aspects of classical antiquity. The bearded figure, who can be identified as Seth, the oldest of Adam's surviving sons, wears a toga-like drape. The figure facing forward wears a lion skin, with paws knotted at the neck and groin, in the manner of Hercules;

Piero actually used it for a Hercules, the only secular figure he ever painted (Isabella Stewart Gardener Museum, Boston). The nude boy seen from behind can be compared to a class of antique statues who mourn, boys at a hero's grave, or winged putti with down-turned torches, spirit guardians of tombs. Defining this pose is a mellifluous outline (actually incised in the plaster) with delicate modeling that describes the pulsing muscles and living tones of the forms. The quality of this delineation is equally classical, reminiscent of Roman vase painting. Arezzo had been famous for its pottery in antiquity, and Piero could have seen some fine examples when an ancient kiln was unearthed there in the mid-fifteenth century.

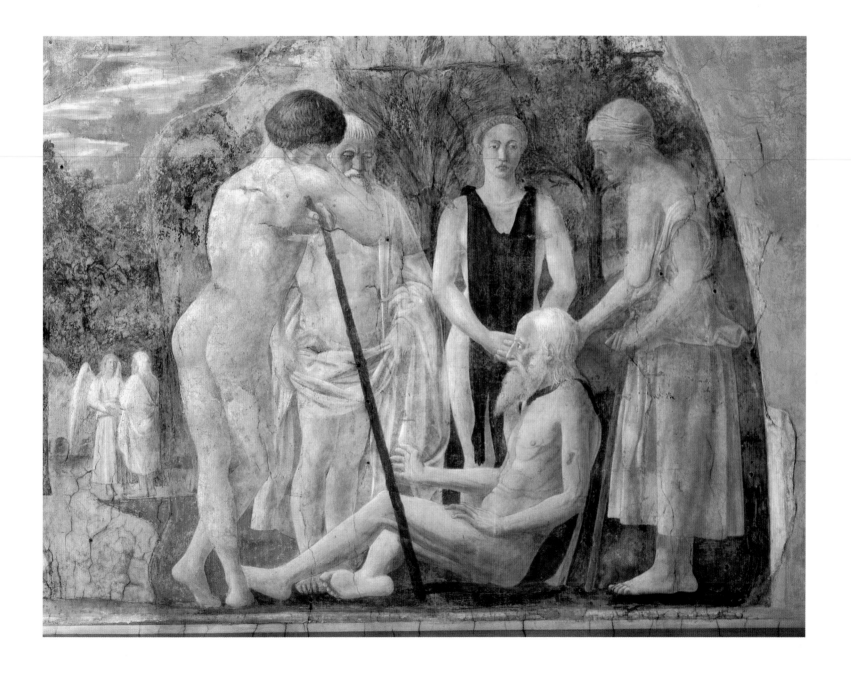

4. Two Boys
detail of the Story of Adam

In the far left corner of the lunette two boys stand together in a kind of embrace. They are among the best preserved figures on the tier in terms of surface effects. The young man in animal skin seen in profile shows traces of pouncing along the cheek and eye; these dots guided the artist as he created the foreshortening in the turning of the forms. The face is darkly shadowed yet vibrant with backlight, as he stares open-mouthed and inward toward the tragic scene. As a foil against the darkness, his blond brother is aglow with direct light (beaming from the direction of the real window). His three-quarter face is modulated with a ruddy tone and the stippling of self-cast shadow. He stares outward, spellbound, as if called by another voice. Indeed, his gaze is focused out across the corner of the space, toward the figure of a prophet holding a scroll (fig. 20; pl. 31b). It is as though this beautiful, round-eyed boy, dressed in a bare-breasted white chiton, were transfixed by the news of the coming of the Savior.

Observing the interaction of figures that spans the space across the corner helps to define Piero's attitude toward his architectural ambient. He does not see the walls as closed surfaces; he never paints a frame between his scenes. Rather, he takes the structure as an open universe, where relationships can be two- or three-dimensional in space, clinging to a pictorial surface as well as receding deeply into a fictive spatial realm.

Fig. 20. Rib between right wall and right side of altar wall showing relationship between *Two Boys* in the *Story of Adam* and the *Prophet Jeremiah* (?), San Francesco, Arezzo. See also pl. 31b.

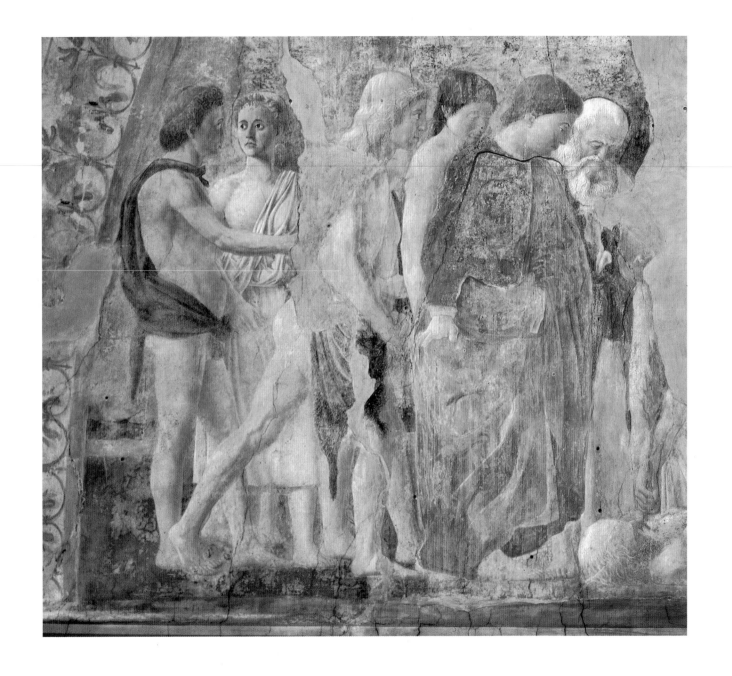

5. Story of Sheba and Solomon

In the second tier on the right, the queen of Sheba makes her famous journey from far away in the Orient to "try the wisdom of Solomon with hard questions." Again the mode is "continuous," with the queen appearing twice in two unified yet highly differentiated spatial areas. The movement of her journey is suggested by a landscape of distant hills, a broad and empty valley, and the switch to reading from left to right. The open area stops at the Siloah pond where Sheba, wearing a blue mantel, sees the wooden beam, kneels, and worships it. It should be noted that the beam is placed perpendicular to the picture plane and on axis with its prototype, the spreading tree, in the tier above. The right half of the tier is set in an architectural framework, a Corinthian portico of grand proportions representing the fabled palace of Solomon. This classical structure is viewed head on, up to the frieze and flush with the picture plane. It is the left side of a colonnade, displayed in sharp foreshortening, that divides the scenes without interruption. The colonnade itself is made of simple fluted supports and evenly lit. What is astonishing about this audience hall is its width. The marble-lined precinct is roofed with impossibly long lintels and a stone ceiling so heavy it could never have been supported. It is, in short, Solomonic architecture, mythologically ponderous and grand, an appropriate abode for the legendary king. The two-part organization of the tier, balancing background landscape with close-up architecture as the setting for a prescient queen who miraculously knows the holy wood and worships it, will be matched closely in its counterpart, the *Invention of the Cross*, on the opposite wall (pl. 20).

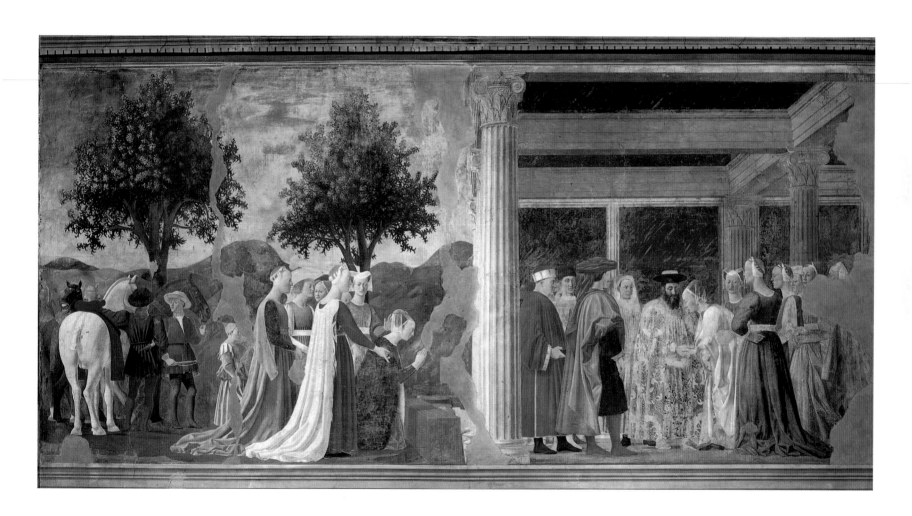

6. Sheba's Grooms
detail of the Story of Sheba and Solomon

When Sheba sees the wooden bridge, the group of travelers comes to a halt. At the far left two grooms attend their sturdy mounts in symmetrically opposite, *contrapposto* poses. One is seen from the front, one from the back; one boy is dressed in gray and red, one in red and gray. Their costumes are depicted with infinite care: their jackets, belts, and *calzone* (stockings) are trim-fitting; their hats are made of tufted wool, each tuft painted with a separate stroke. The well-chosen cock of their hats give the boys a proficient, vigilant air. The horses too are counterpoised, one seen in strong foreshortening from the back. Again, close observation reveals Piero's immaculate preparation in pouncing dots along the edges of the forms. Moreover, around many of the dark contours a thin border of white *intonaco* has been reserved, giving an extra thrust that propels the shapes into high relief.

The grooms observe the miraculous event with measured glances, their stationary poses adding to the solemnity of the occasion. But their cool objectivity in controlling the animals does not prevent one of the black horses from breaking the silence. The one farthest to the left looks up, opens his lips, shows his teeth, and whinnies. In Piero's conception even this breach of decorum has significance. What that meaning is, we will see in a moment.

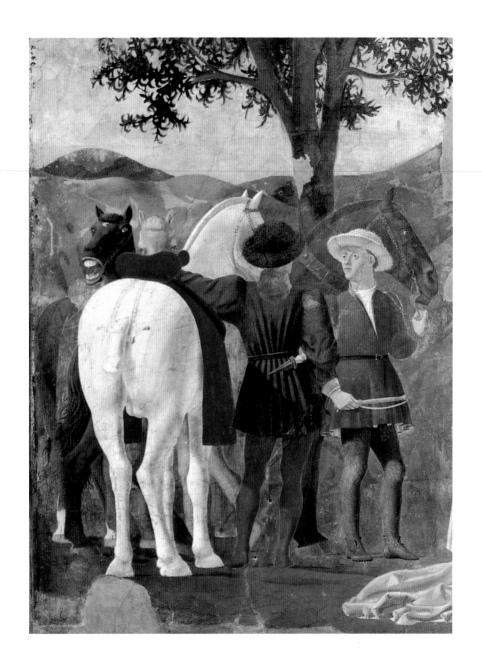

7. Recognition of the Holy Wood
detail of the Story of Sheba and Solomon

Two leafy trees form a hypaethral sanctuary where the queen, a crown around her veiled, high-piled hair, kneels in veneration before the wood. Her ladies-in-waiting and one small slave in a pointed cap gesture in amazement at the miracle. Perhaps more than any of his other figures, these women characterize Piero's model of perfection. Their sartorial splendor is renowned: gowns of tinted greens and reds with high waistlines, softly bound breasts, and trailing cloaks of weighted fabrics. Columnar necks support ovoid skulls shaved at the brow and covered with tightly braided tresses lashed with ribbons, ears netted in modesty. These women are the fulfillment of dreams: beings intent on truth, using words sparingly, showing the dignity and purpose of human intelligence.

As formal units, the figures populate the picture plane; the wedged-in woman with forked hairdo, for example, fills out the flat mosaic of surface patterns made up of faces. The reserve spaces between the forms have solidity equal to that of the figures. But the forms also exist as palpable volumes and create an imaginary space that exists behind the plane. Following the theories of Plato, Piero made all forms universal "regular bodies": cylinders for legs; each head a perfect sphere; the wood not a natural log but consciously crafted into a parallelepiped. In giving his forms abstract perfection, he brings time to an absolute standstill, turning action into ritual and meaning into holy celebration.

Piero must have understood the flawlessness of this composition in realizing his ideal. And for some of the same purposes, he reused the rhythmic interweaving of the figures, their identity, their solemn gestures, and their powerful sense of concentration in the second episode of this chapter.

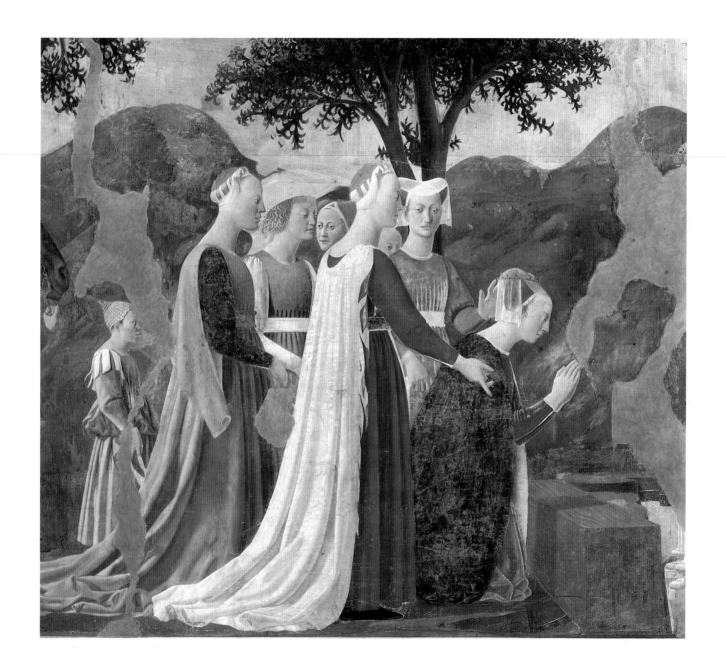

8. Meeting of Sheba and Solomon
detail of the Story of Sheba and Solomon

The monarchs in this regal setting greet each other with a handshake. While this gesture ordinarily designates equality, Sheba bends to lower herself before Solomon's superior wisdom. Her maidens watch in heavy silence, once more recognizing the ritual meaning of the encounter. St. Ambrose had commented on the meaning in a well-known homily on Luke: 11, read in the Roman breviary during the first week of Lent and as the lesson for Wednesdays: "The Church is a Queen and the meeting of Solomon and the Queen is a great symbol of Christ's marriage to the Church." In the fresco Sheba has removed her dark dress and heavy blue mantle and is now dressed all in white; the handshake also signifies marriage.

As has often been observed, Sheba and her ladies-in-waiting are drawn from the same cartoon as the women in the adjacent *Recognition* scene; the cartoon was simply turned over to reverse the design. With this ingenious technique, and a few changes for variety, not only did Piero weave the extraordinary *Meeting* scene into the narrative, but he also emphasized its equally miraculous quality.

The king is dressed in royal robes and has the hat and features of an Old Testament character. His counselors, however, add a note of contemporaneity to the proceedings by wearing fifteenth-century styles: a fat burgher in red to the left, another younger man in a modish mauve turban, and a tall, thin-faced man in a simple cap who may be Piero's self-portrait.

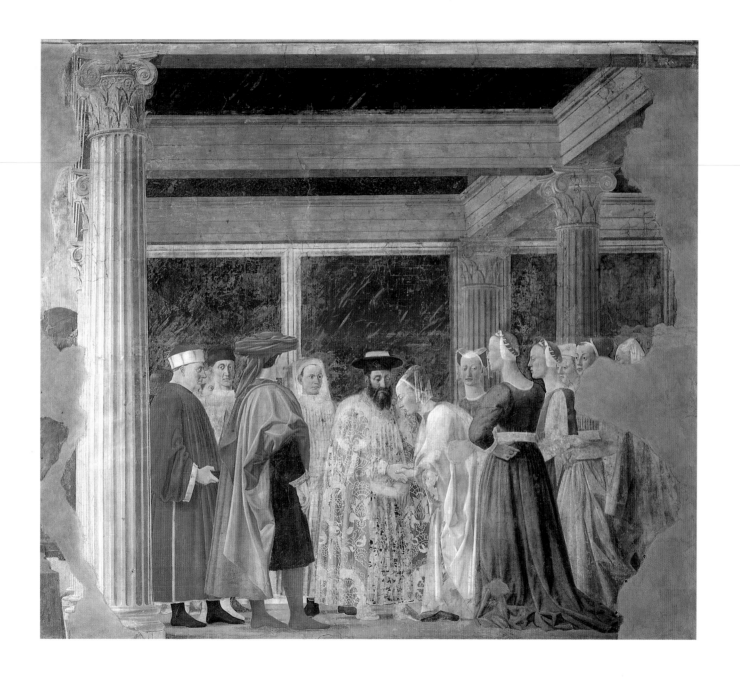

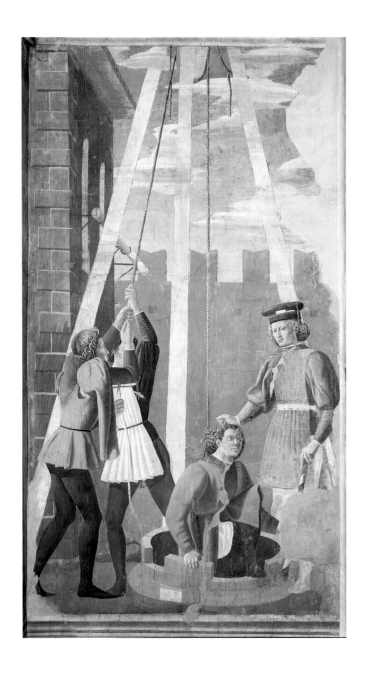

9a. Raising of Judas from the Well

The scenes on the altar wall are long, vertical rectangles, quite different from the laterally extended compositions of the side walls. The vertical format has a different focus requiring, almost by its very nature, a monoscenic composition. It is clear that the altar wall scenes form pairs on each tier on opposite sides of the window. In the *Burial of the Wood* we are in a landscape of a rather abstract nature. The men who are pushing a plank of wood down toward the center of the wall are on dry ground. They push the wood out of the picture field into the imaginary extension of the pool, which is edged in a threatening shade of red and reflects some teeth-like plant along shallows. Behind them a celestial blue sky is streaked with clouds.

The landscape is in symbiotic opposition to the urban setting of the *Raising of Judas*, its alter ego on the left. The backdrop

Fig. 21. Boccaccio, "The Story of Andreuccio," *Decamerone*, Stampa di Gregori, Venice.

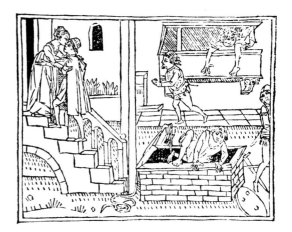

9b. Burial of the Wood

here is a crenellated pink wall that blocks the view into the distance and the façade of a dark stone building. The corner of this house is edged with rather elegant rusticated quoins, and the angle reverses the angle of the real corner from which it protrudes. Young dandies wearing very fancy clothes (colored *calzone*, variegated sleeves) are pulling down on the single-fixed pulley to bring the prisoner up. The dry well out of which Judas is rising is the circular counterpart of the wet pool in the *Burial* scene. Both scenes are structurally dependent on strong diagonals—the plank of wood on the right, the supporting blocks of the pulley on the left—each extending beyond the margins of the painted field. Together they form part of the "X" pattern (cat's cradle) that underlies the composition of the whole altar wall.

Although rather crisply painted and certainly well conceived, some of the actual details of these scenes appear more harsh and unpoetic in effect than others. Piero would have designed the scenes and supervised the making of the cartoons, but because of the lack of pictorial refinement, the actual execution has been attributed to Giovanni da Piamonte, one of his documented assistants. It is very possible that this man was chosen to do the painting of lowlife types specifically because he worked in a style that was similar to, but much cruder than, Piero's.

10. Workmen
detail of the Burial of the Wood (colorplate)

The lowbrow workmen whose shabby clothes are in disarray are among the first such ruffians to appear in Italian art on a monumental scale. Their rowdy character is further emphasized by another juxtaposition, with the left end of the Sheba episode, in the corner of the architectural space. There, the red-stockinged, bewreathed drunkard's backside is compared directly to the rear end of a horse! Could it be that this comparison is what causes the black horse on the right wall to whinny? Was there a proverb in fifteenth-century Tuscany that said a "horse's ass" elicits a "horse laugh?" This author doesn't know, but it seems as if Piero thought it was a good idea. Thus, as on the lunette level above, he used a real spatial relationship, scenes juxtaposed in a corner, to add another dimension to his narrative.

Yet, as is often claimed, the visual configuration of the scene on the altar wall also conjures thoughts of a more serious nature. Details of the plank of wood include the carefully drawn pattern of its grain. The concentric rings fall behind the first workman's head and provide him, fortuitously, with a halo. The configuration then of head, halo, and diagonal plank of wood suggests images of *Christ Carrying the Cross*. In an ironic manner the scene thus becomes a foreshadowing of Christ's Passion.

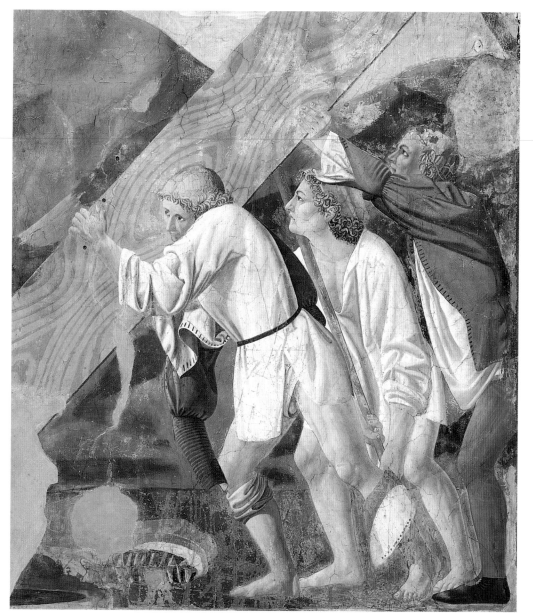

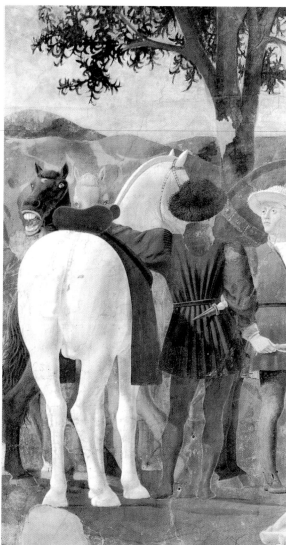

Detail of *Sheba's Grooms* from the *Story of Sheba and Solomon* (pl. 6).

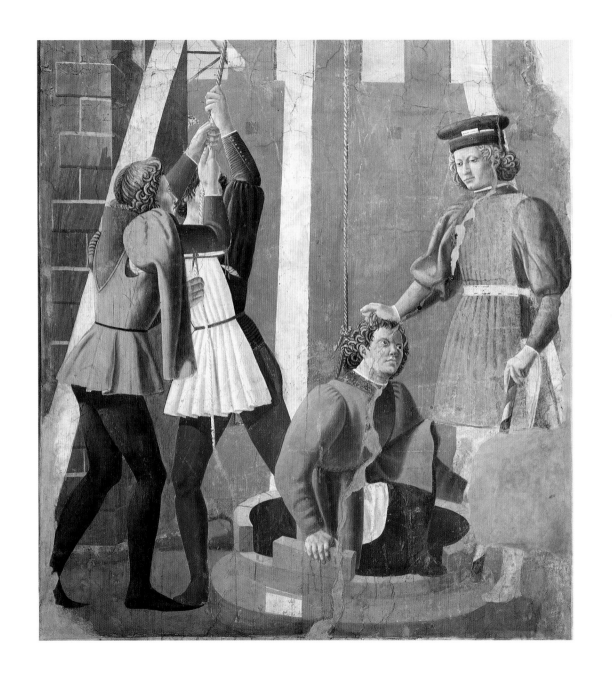

11. Judas Pulled Up by the Hair
detail of the Raising of Judas from the Well

We have already, in the Introduction, pointed out the comic source of this scene in Boccaccio's *Decamerone*. Here we turn to its more serious aspect. What Piero left out of this part of the story was Helena's forceful discussions with the Jews of Jerusalem, whom she accused of withholding information concerning the whereabouts of the Cross. They finally pointed out Judas as the only one to have the information. Unbeknown to the Jewish leaders, Judas (who was the grandson of St. Steven's brother) was a secret Christian, hence his knowledge of the Cross. He refused to answer Helena for fear that she would desecrate the relic. Only after torture did he offer up the truth.

The scene shows Judas, neatly jacketed, under the surveillance of a senior official as he emerges from the well. Now it is the manner of his extrication that is arresting: the official grasps Judas by the hair to haul him up. The allusion here is to another Old Testament transportation, the method by which the prophet Habakkuk was taken to Daniel by an angel. Habakkuk was fulfilling his duty—that is, he was on his way to feed workers in the field—when the angel took him. He struggled since, having no idea what the purpose was, he did not wish to go. In the end his new mission was a higher good: to save Daniel in the den. A scene of this encounter was fully visible in Rome when Piero was there in 1458–59, on the famous

Fig. 22. *Habakkuk Carried by an Angel*, detail, wooden doors, Santa Sabina, Rome.

Early Christian wooden doors of Santa Sabina (fig. 22). Piero used the same gesture to liken Judas to the prophet: Judas struggled in the well because he did not yet understand he was being taken by force for a higher good.

The handsome officer on the right shows his rank with a superior air, with his splendid blue overblouse, and by the way he leans on his spiral-striped baton of authority. There is a ticket in his hat inscribed with what looks like the word for "prudence" (or *prude[n] ti vinco* [with prudence I conquer you]; the inclusion of the word *vinco* is surely a play on the word for victory inscribed on Constantine's labarum, which extraordinarily is not represented in the cycle; see commentary on pl. 15). More than likely, the virtue belongs to Judas. As opposed to his evil namesake, the new Judas soon shows his prudence in a change of heart: he becomes Helena's confident and leads her to the Cross. Thereafter he is ordained and later appointed bishop of Jerusalem with the name Cyriacus. Again, the somewhat awkward execution is attributed to Giovanni da Piamonte, and is suited to the scene's lowbrow character.

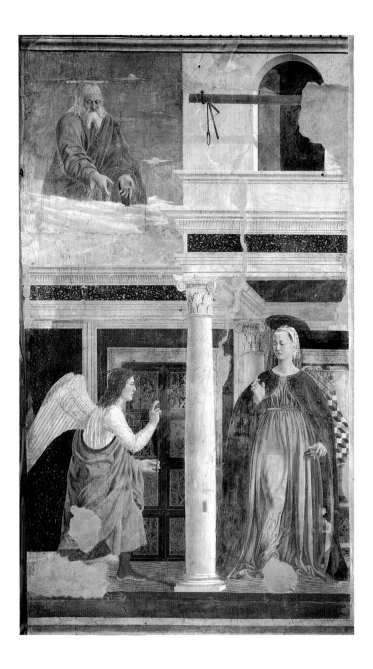

12a. Annunciation

The two scenes on the lowest register of the altar wall are again paired. They are both annunciations in which the divine message enters in visible form from the upper left. To the left of the window, Gabriel announces the beginning of salvation through Christ's sacrifice, as golden rays descend from the hands of God the Father; on the right, an angel brings Constantine a cross to announce the beginning of Christianity as the official religion and the founding of the Christian state.

In this case the two settings are diverse kinds of architecture: one, the *Casa Santa* (Holy House) of Mary, shown as classical in style and permanent; the other, Constantine's field pavilion, military and temporary. Surface geometry binds the scenes together and creates a linear directive with which to follow the narrative. Extending the upper horizontal of the elegant green marble frieze of Mary's portico, we find that it coincides with the horizontal support of Constantine's tent. The difference in materials makes this relationship subtle; the precision makes it inevitable. Parallel diagonals of descending light in both scenes also have abstract validity. Like all other scenes in the cycle, the painted light flow in the *Annunciation* follows the path of real light (see the shadow to the left of the column) coming from the window. The opposition between the directions of illumination and incarnation reinforces the spiritual merit of the message. On the second story of the house a window is crossed by a bar of heavy wood. Although the same motif appears several times in the cycle, here it

12b. Constantine's Vision

represents an epithet for Mary. The *fenestra cancellata*, or barred window, described in the "Song of Songs" is a reference to the Virgin birth. Silhouetted against the wall, the bar's shadow seems miraculously to pass through an empty tapestry ring hanging from a strut; this image too refers to the miracle of conception in Mary, "ever virgin." The scene thus shows the beginning of Christ's life on earth, and explicates the *Annunciation* as the connecting link between the two halves of the story of the Cross. Reference to the Cross, moreover, is quite explicit in the structure of the composition as a whole. The field is divided into quadrants by the central column and the strongly accented crossbar of the serpentine frieze. The structure of the Constantine scene also makes reference to the Cross not only explicitly in the symbol the angel brings, but implicitly in the design of Constantine's tent, as we shall see.

The scenes together constitute the other part of the "X" of the cat's cradle pattern, the whole of which is meant to draw all the scenes together. Extending the diagonal downward from the plank of the wood in the *Burial* (pl. 9b), the line coincides with the crucial juncture of the column base and the floor. The extended diagonal of one of the pulley blocks in the *Judas* scene follows the same path as Constantine's angel's flight. All four scenes are thus drawn together into harmonious union: the pattern binds together the Old Testament with the New, and worldly history with the world of apocryphal legend.

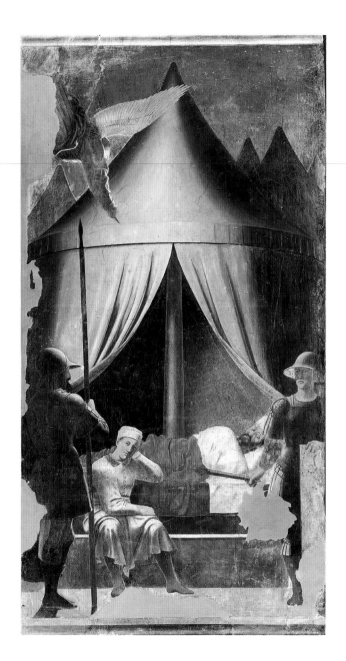

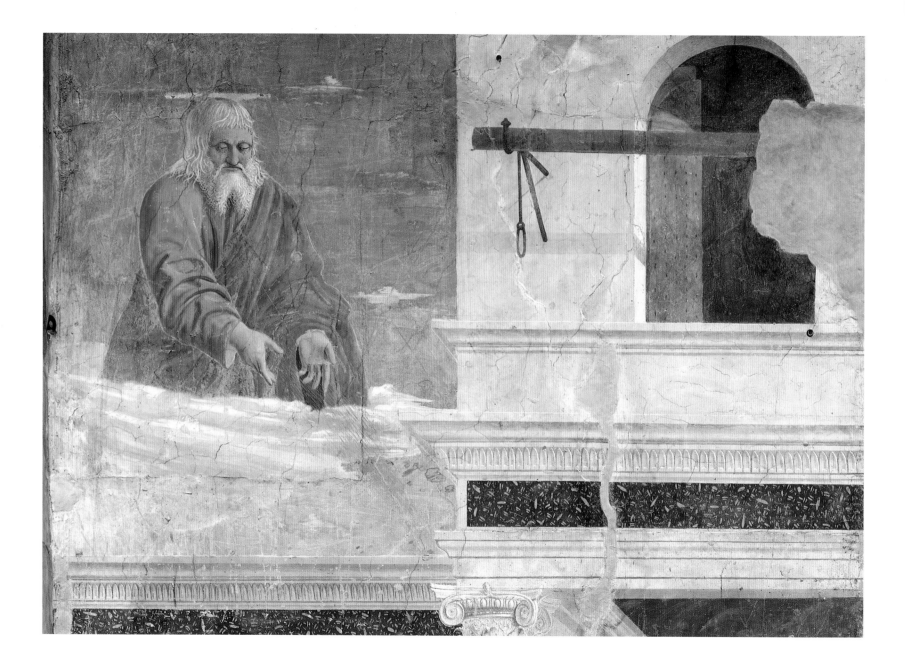

13. God the Father
detail of the Annunciation

Piero represents God the Father, a partial figure in a red gown and blue mantle, hovering on shadow-casting clouds in the upper left corner of the scene. Relatively rare in *Annunciation* scenes, God's presence here refers to his debate with the angels on when to initiate the scheme of salvation, about which there were ambivalent emotions. The angels prevailed, and God issued the order to Gabriel to descend to Mary. The angel gave the message, but it was from the Lord himself that the glorious impregnating rays descended. Piero gives the figure of God a gesture of release, hands together extended out before him, with the spirit descending mysteriously on rays of gold. Much of this eminence has flaked away; originally the effect would have been dazzling.

The physiognomy of God is that of a distinguished elder citizen but loftier. He is robust of feature, with a square brow, deep-set eyes, broad and substantial nose over a modest, down-turning mouth. He has a goodly head of strong, white, curling hair, a thin moustache, and a beard, the locks of which are forked into two points. His halo is seen in sharp perspective from the edge. He has an air of authority yet is not unkindly; he concentrates on his momentous act and yet is somehow gentle in the doing. By placing him above the parapet of Mary's house, Piero puts him in a heavenly realm, but because of scale and the nature of the four-part composition, he remains nearby and eminently approachable. As always, Piero manages to create an image that is at once particular and enduring.

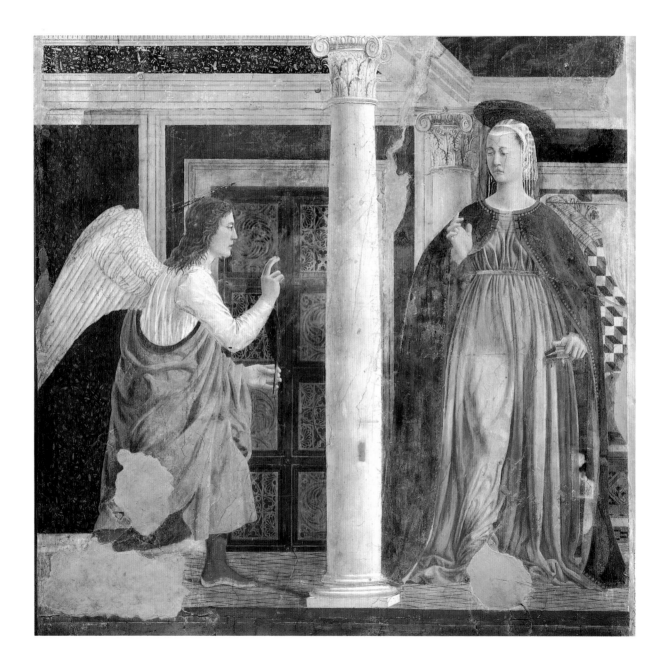

14. The Virgin and Angel
detail of the Annunciation

Neither standing nor kneeling, Gabriel is in the process of arriving on earth, with one foot on the ground (the second foot is lost, but can be reconstructed as touching only a toe). As he enters the paved forecourt of Mary's house, he blesses with one hand and carries a palm branch in the other (originally green, now oxidized). His raised hand is silhouetted against a doorway intricately carved with whirling geometric patterns. This portal (which was recently discovered to be painted with oils in the lower half) is a reference to the gate described by the prophet Ezekiel (44:1–3) as the one "through which only God can enter." As the *Janua Caeli* (Doorway of Heaven) it is again an epithet of Mary's eternal virginity. The palm frond in Gabriel's hand, by contrast, does not announce the Incarnation of Christ, but rather the future death of Mary. The palm, by tradition, is the key to Paradise, lost when Eve sinned but returned when Mary died. The sin of "Eva" is reversed as the angel utters his greeting, "Ave." In this way, the *Annunciation* is related to the opening scene of the cycle.

But even as Mary begins her mission, Piero makes sure her destiny as co-redemptress is defined: as the representative of every member of the church, her death and assumption guarantee the salvation of mankind. In this way the *Annunciation* was related to the wooden crucifix hanging nearby, where, at the very top, a bust of the *Assunta* was represented (see frontispiece).

The construction of Mary's figure, gesturing in surprise and resignation, expresses the same concepts. As a figure she has the same perfection of shape as her sisters on the right wall; suffering the foreknowledge of the Passion, she is only somewhat less ideally tranquil. Her meditation has been interrupted; with her finger, she holds the place in her book. In rational terms, however, her monumental form is much too large for the portico, reaching almost to the ceiling. She and the adjacent snow-white column share a swelling entasis. The Corinthian shaft, breaking long-standing architectural law, remains unfluted; again, Mary's unbroken virginity responds. In her red gown and royal blue mantle edged with pearls, she is thus shown as a symbol of Ecclesia, pillar and body of the church as an institution. As such, her marriage to Christ (theologically said to take place at the moment of Incarnation) is evoked in the diaper-patterned inlay wall and bower-like vaulted ceiling of the bedroom partially visible behind her. Her marriage bed is prepared; "the King hath brought me into his chambers" (Canticle 1:4). In this way, the meaning of the *Annunciation* is related to the meaning of the *Meeting of Sheba and Solomon.*

If Piero did receive a mandate to include this subject, one normally not part of the story he was commissioned to paint, he not only succeeded in making it fit, but also made it seem that the cycle would be incomplete without it.

15. Angel of Constantine's Vision

A number of early Christian historians give accounts of Emperor Constantine's vision of the Cross, all differing slightly in details of locale, time, and the form of the vision. They all involve a heavenly visitor, either Christ or an angel; they all repeat the words Constantine hears, "*In hoc signo vinces*" [IHS] (By this sign you shall conquer). Piero drew on these accounts to devise an image that is essentially his own. He makes no reference to the famous words, and he broadens the theme, raising it above the narrative, to show that Constantine's victory went beyond the bounds of war.

In one of the first night scenes in monumental painting the mighty general is disarmed and asleep in his yellow military tent with its mauve pavilion top. The tent shape is repeated several times, producing the effect of a large encampment. In the silence of the night, an angel dashes down holding a tiny golden cross from which emanates a radiance that fills the night and brings the figures into view. He extends his right arm below him, making a strange gesture with his hand: the little finger points diagonally down; the other fingers make a fist (their outlines are visible below the little finger); and he holds the small cross upright with his thumb and clenched

fingers. He is, in effect, doing two things at once: displaying the cross in a way that lets its radiance emanate without obstruction and pointing at the person to whom the message is given (the diagonal of the extended finger arrives at Constantine's face).

Fig. 23. Photograph, demonstration of the position of the hand of Piero's angel.

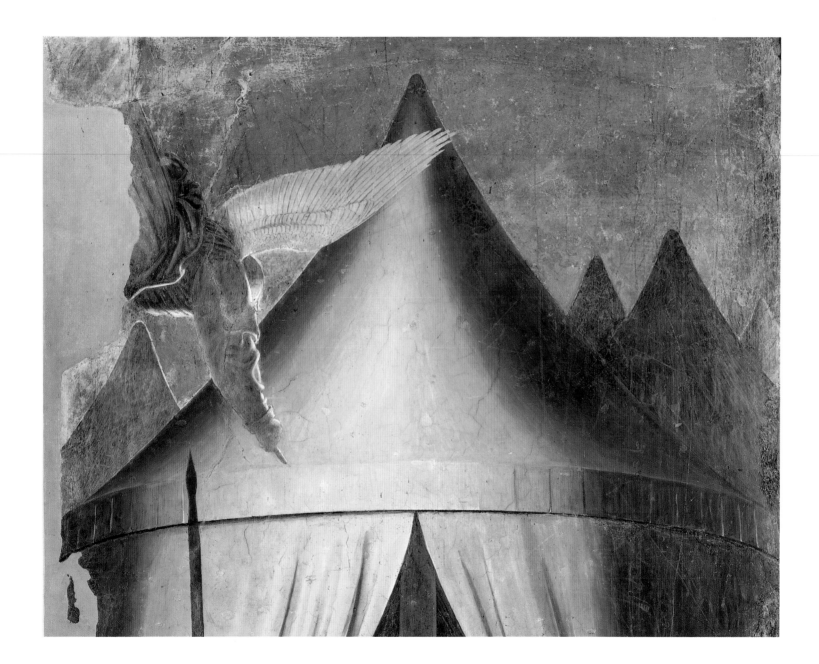

16. Soldiers and Sleeping Constantine
detail of Constantine's Vision

Constantine's sleep is placid but illuminated; his eyes are closed but we see what he dreams. Under his dark red cover and white sheet, he reclines across the diameter of the tent, his body perpendicular to the tent pole. In this position he resembles nothing so much as the often-represented figure of the dead Adam at the foot of the Cross in Crucifixion scenes (fig. 24), where he symbolizes the sin for which Christ's sacrifice is a replacement. The allusion is a parallel to the *Ave*/Eva metaphor in the *Annunciation*. On the platform of the bed, a blue-collared body-servant sitting with his head resting on his hand is another funereal allusion. The pose is often seen on antique sarcophagi and in other deathbed scenes of melancholy mourning (fig. 25).

The mystery is augmented by the placement of the stalwart guards. One, with his back turned, approaches with a spear; the other, facing out, threatens with his weapon raised. Their counterpoint lighting adds to the sense of their military prowess. As they take their posts, their bodies hide the lacings of the tent. As a result the flaps seem miraculously suspended, and the sleeping Constantine appears as in a revelation. What we are witnessing is the death of paganism on the eve of Christian victory, not just over worldly enemies but over death itself.

It would be more than a century before the element of light would be used again with so much dramatic force. Not until the time of Caravaggio in the first years of the seventeenth century would artists give light such a creative role. Beyond the purely dramatic, however, Piero defines the light from a logical point of view: knowledge replaces ignorance as light does darkness. He used the simile one other time in his career, in a scene representing the *Stigmatization of St. Francis*, a predella on the *St. Anthony Altarpiece*, Perugia.

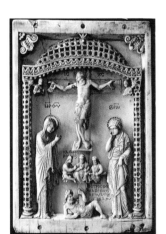

Fig. 24. *Crucifixion of Christ with the Dead Adam*, Metropolitan Museum of Art, New York.

Fig. 25. Masolino, *Death of St. Ambrose*, San Clemente, Sacrament Chapel, Rome.

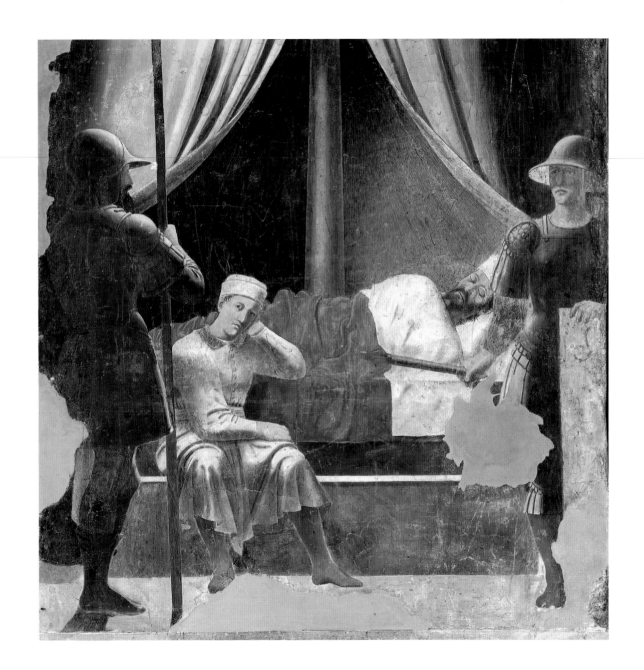

17. Victory of Constantine

As the plot turns the corner and passes onto the bottom tier of the right wall, immobility suddenly erupts into animated movement. From somewhere behind the standing guard in the corner, part of a horse's head, posed for motion, emerges (see Introduction, fig. 13). For the third time in the series Piero uses abutting walls as a point of meaningful juncture. With no arbitrary framing in the corner, the partial forms at first seem sliced off. Their fragmentation is not unlike the pictorial effect often used in painted chivalric cycles, where interpenetrating space and rapid change in visual speed are

basic parts of the narrative technique. Jousting episodes that turn the corner by Pisanello, discovered in the 1960s in the Ducal Palace at Mantua, are near-contemporary examples (fig. 26). Piero uses this approach, it seems, to ensure recognition of the similarity in subjects. But with this juxtaposition he also points out the similarity in the horse and the soldier: they are both members of the recently converted Christian army.

Fig. 26. Antonio Pisanello, detail, *Chivalric Fresco*, Palazzo Ducale, Salone, corner view, Mantua.

The military encounter fills the tier as one uninterrupted scene. After starting at a rapid pace, the procession slows to a crescendo of immobility in the center, followed by a void and then flight. In their fright at the tiny sign of the cross (now lined up vertically with the log and the tree), the enemy troops forget the trap they had laid in the river, fall in it, and are thus defeated by their own wiles. Much of the right side of the tier is unreadable, greatly damaged by dampness and inept restoration. More of the composition can be seen in a watercolor copy made about 1820, when the fresco's condition was better (fig. 27). From the little sketch we know that Maxentius is the figure on the right bank under the flag; he wears the same peaked hat as Constantine but with colors reversed (here the crown is green and the brim red; see the next plate). Behind him one of his cavalrymen still struggles in the water, and at his side is a naked barbarian aide who flees bareback on a mangy white horse.

Fig. 27. Johann Antoine Ramboux, watercolor copy of Piero's *Victory of Constantine*, ca.1820, Graphische Sammlung, Dusseldorf.

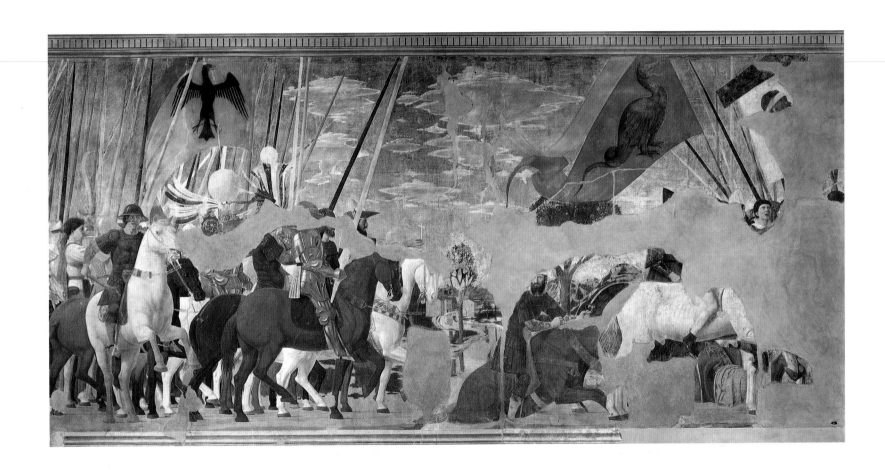

18. Flags and Lances
detail of the Victory of Constantine

The battle starts as a captain on a rearing horse and bare-headed trumpeter signal the charge. The captain with a mace has the face of a professional soldier, aggressive and battle-scarred (the marks around his mouth are surface damages). The features of the curly-haired trumpeter look Norman. The many lance points held on high once again give the impression of more people than are actually represented. The new age we have entered is signaled by another costume change. Now in the late classical period, many of the military men sport Roman armor, molded leather cuirasses, strip skirts, greaves, and helmets. However, others are dressed again as contemporaries, wearing full suits of fifteenth-century laminated steel. Piero seems to have been interested in how these suits functioned; he painted them several times in his career. Perhaps the abstract shapes and reflective surface delighted him. In any case, he included many suits in the cycle in both this scene and, across the chapel, in the *Battle of Heraclius*. All the riders have stirrups, a convenience quite incorrect for classical equestrians.

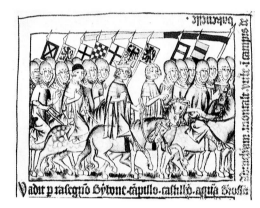

Fig. 28. *Heinrichs VII, Battle at the Milvian Bridge,* Koblenz Staatsarchiv.

Constantine's army is brought together under a single huge banner: a black spread-winged eagle, head turned right, beak open, on a field of yellow-gold. The emblem is that of the victor, regal, Roman, and full of *virtù*. By contrast, the two flags that furl over Maxentius and his troupe are adversarial, one emblazoned with an evil basilisk and the other with the head of a Moor. In a common heraldic language these billowing pennants make their comments by filling the upper regions of the space with airy movement.

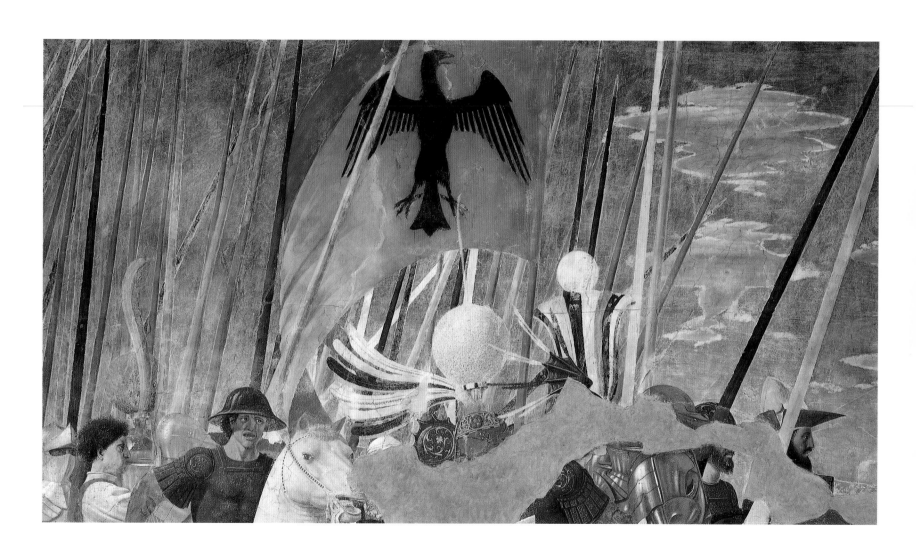

19. Head of Constantine and Two Horses
detail of the Victory of Constantine

Piero rivets Constantine in place with the great, long lance of the fully armored knight. Passing across his head at a sharp angle, the shaft creates a magnificent tension, focusing on the regal bearing of the monarch. By overlaying the reined-in white steed with a chestnut-colored horse, Piero adds to the sense of pent-up force. At this moment of wonder nothing moves. By good fortune, what is best preserved in this composition is Constantine's face, with all its stunning colored modeling. The virile black beard that frames the chin is answered by the razor-sharp green visor at his brow. Indicating imminent victory, the pointed pink dome of the hat is already circled by a crown.

For generations art historians have discussed the striking resemblance of Constantine's profile to that of John VIII Paleologus, emperor of Byzantium (d. 1448), following the mode of Pisanello's famous medal (fig. 29). In fact, there are earlier images that are equally pertinent; for example, the head of *Totila's Guard* (fig. 30) in Spinello Aretino's cycle of St. Benedict. For the foreign soldier at the moment of his conversion, Spinello composed a profile face with peaked hat with folded brim and dark hair and beard sharply pointed in the front. Possibly all three artists were relying on a generic type for rulers from some distant time or place.

But if there is a Paleologan reference, it would have current resonance. John VIII had come to Italy in 1438–39 to attend the Council of Union in a effort to bring together the Eastern and Western churches. He also sought help in fighting off the Turks. In the end both efforts failed. Paleologus was unsuccessful in gaining ratification of the document of union from his own church patriarchs; after he returned to Constantinople, he spent the rest of his life in a depressed torpor. In 1453 Constantinople fell to the Turks. A few year later, in Italy, there was heavy papal pressure for a new crusade against the same enemy, and no doubt with the physiognomic allusion, in a generic way, Piero refers to these events. Thus, by representing Constantine, in battle with a pagan enemy, with the features of a Christian heir to the Roman Empire, Piero gave his scene a historical status it could not otherwise have achieved. But we still have to ask what the meaning of the allusions were for Arezzo.

 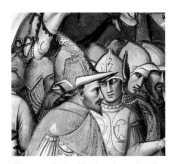

Fig. 29. Antonio Pisanello, *Medal of John VIII Paleologus*, Louvre, Cabinet des Medailles, Paris.

Fig. 30. Spinello Aretino, detail, *Totila's Guard*, San Miniato, sacristy, Florence.

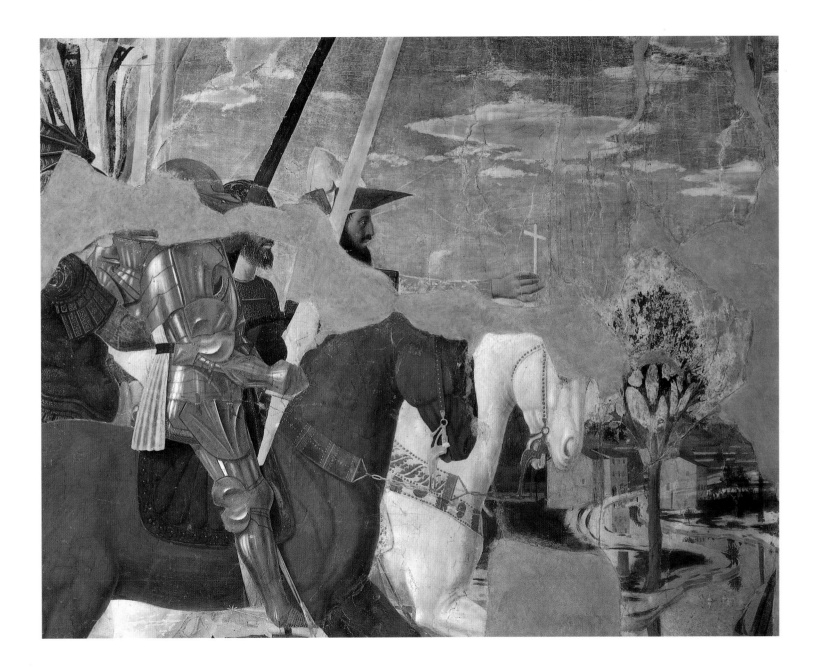

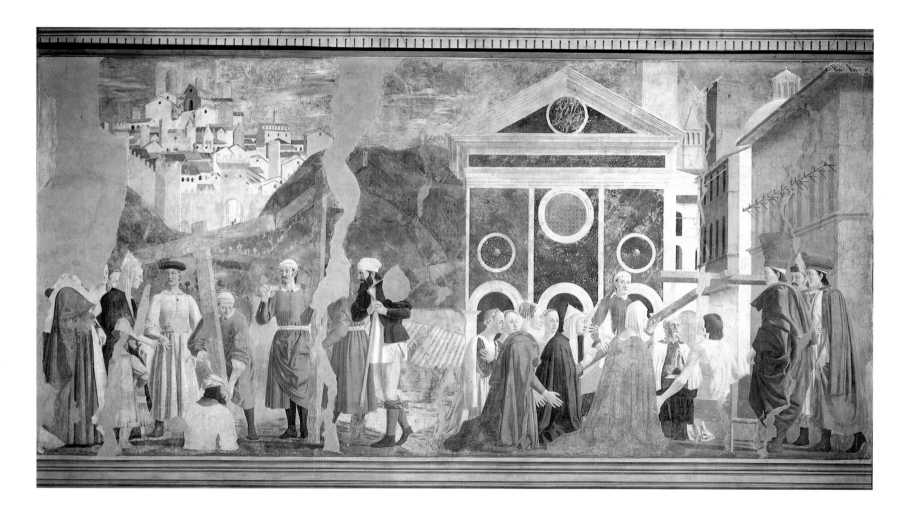

20. Invention of the Cross
(Finding and Proofing of the Cross)

The two episodes that make up the Feast of the Invention of the Cross (May 3), the Finding and the Proofing of the Cross, are traditionally shown together as a two-part composition; so they are on Piero's second tier left. In compositional structure the tier matches its partner, the *Story of Sheba and Solomon*, on the opposite wall, sharing a landscape background on the left with an elaborately orchestrated architectural setting on the right. The leading character is again a woman of royal blood, whose experience is divinely inspired recognition of the wood.

In the *Finding* scene, St. Helena's aristocratic status is emphasized by the presence of Marcarius, bishop of Jerusalem (the area of his head is ruined), and members of her court, including a well-dressed dwarf with a fancy hat—again in the style of Paleologus!

They have gathered at the burial place of the three crosses from Mount Calvary, following the directions of Judas. The digging is carried out by hefty workmen, some of whom are clearly identified as Semitic by their features. One man half-submerged in the pit he is digging is shaped like a Renaissance bust seen from behind; he has discovered a cross and is being helped to lift it up. Three other laborers observe the work; one holds the first cross found; one with a great black beard, his bare legs quite exposed, simply leans on his shovel. The proceedings are carried out with immense dignity, the figures forming a semicircle around the central workman. Their concentration, as well as their stereometric structure, unifies the group and cuts across differences in social status.

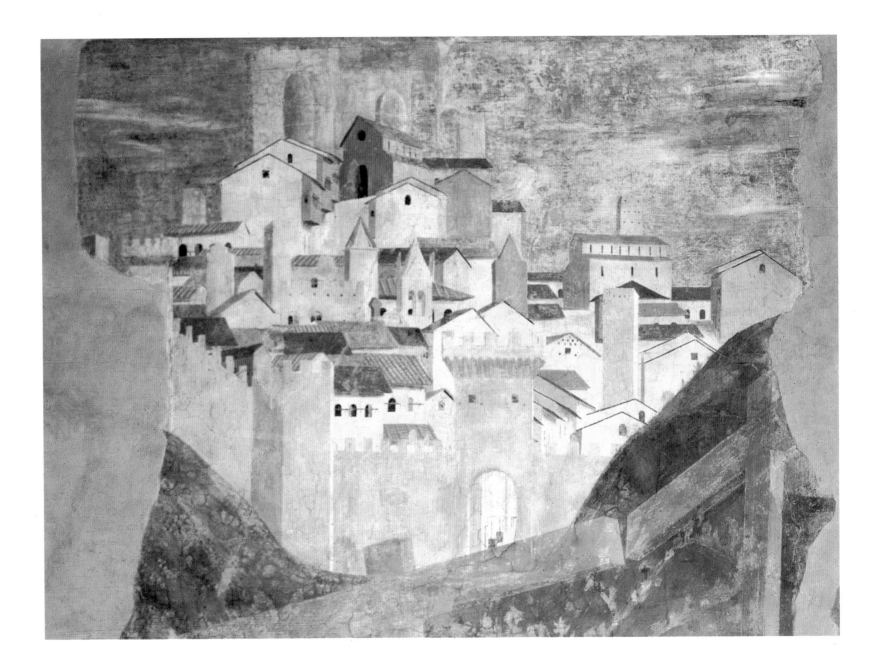

21. The City of Arezzo
detail of the Finding of the Cross

The formal arrangement of the *Finding* places the large, newly found crosses directly juxtaposed to a remarkable cityscape, identified as Arezzo itself. Through these means, the background and foreground are drawn together on the picture plane, graphically expressing the transfer of efficacy from the holy site in Jerusalem to the cycle's real locale in Tuscany. This religious association only reinforces the special allusion to Franciscan exorcism of the city, already discussed on pages 9 and 25.

The city is seen from the southwest as it rises up the hill surrounded by fortress walls. While the view is treated with geometric simplification, emphasizing the structure of the buildings and their vertical relationships, there is a surprising amount of detail in the city gate, the sloping roofs, and the many churches and towers.

This particular detail was part of the painted copy that was placed in the *chapelle* of the Ecole des Beaux-Arts in Paris in 1872. There it must have been admired by Cézanne, among others, whose own *View of Gardanne* (fig. 31), with its rising composition of geometric solids, seems to owe much to it. In turn, this particular composition by Cézanne is said to have inspired directly what are called the "first Cubist landscapes" by Picasso and André Derain.

Fig. 31. Paul Cézanne, *View of Gardanne*, Metropolitan Museum of Art, New York.

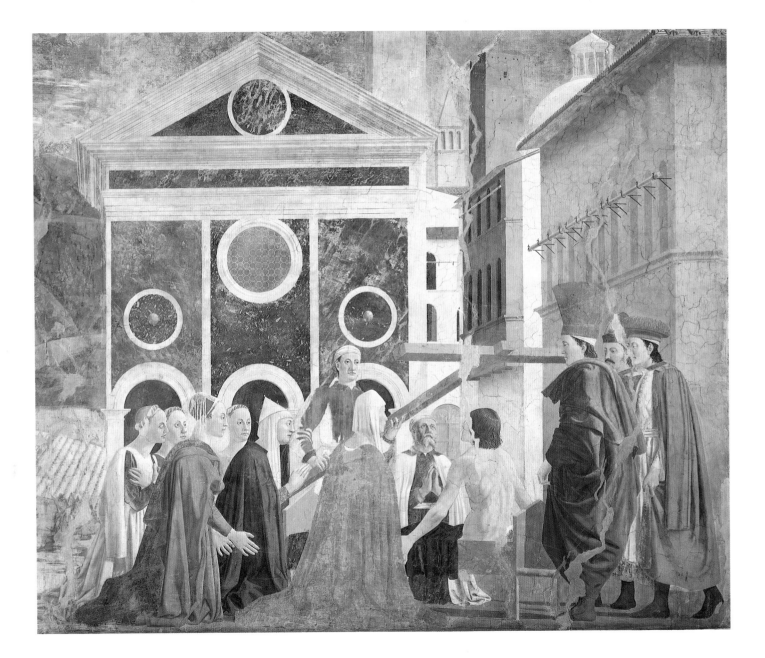

22. Proofing of the Cross

"At the touch of Christ's cross, the corpse rose up and gave thanks." So reads *The Golden Legend* in describing the Proofing of the Cross, when St. Helena had all three crosses placed on the body of a dead youth whose funeral procession was in progress. It is at this moment that the devil is vanquished and flees, "screaming and crying out." The empress and her ladies have fallen to their knees, responding with intense devotion to the splendor of the miracle. Again, Piero creates a scene of potent concentration, with the figures in a circle contemplating the Cross.

The three male witnesses grouped at the right of the *Proofing* are famous for their costumes, in particular for their exotic hats. There are several models, all worn over white turbans: one, a stiff conical bonnet with contrasting brow band; another, mushroom-shaped and made of shaggy fur; and a third, made of a starched material forming a high, stovepipe shape. All this headgear is again culled from the 1438–39 repertory of the Paleologan court. It is possible that Piero saw some of these Byzantine visitors himself, but more probably he knew the bronze reliefs by Antonio Filarete on the Porta Santa of St. Peter's in Rome (fig. 32), set in place in the early 1440s. The little historical reliefs, under large-scale figures of Peter and Paul, document the visit of Paleologus, the Orthodox patriarchs, and their attendants in explicit detail. All this exotica is represented there. Piero was obviously fascinated by these costumes, for he used

them repeatedly in this cycle and also in his panel paintings of the *Flagellation* and *Baptism*. In every instance, however, he followed the tradition of his period, using Byzantine fashions specifically to verify a scene's late antique date and Near Eastern locale.

Although the structure of a "continuous narrative" background composed of landscape and architecture matches this scene's counterpart on the opposite wall, the architectural types differ. In the *Story of Sheba and Solomon* scene (pl. 5) the figures are in an architectural interior, under a ceiling and in front of a wall. Here they inhabit urban space, in front of an elaborate skyline. The miracle of the story occurs in the streets of Jerusalem, where a funeral procession winds its way. The background forecasts a city of the future: marble-encrusted churches and multistoried palaces, regular streets, and a ghostly white Bramantesque dome. Stylistically, Piero's vista is truly prescient: it predicts a new Jerusalem that would be built in Rome by Christian monarchs.

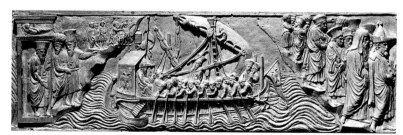

Fig. 32. Antonio Filarete, *Arrival of the Greeks*, doors of St. Peter's, the Vatican.

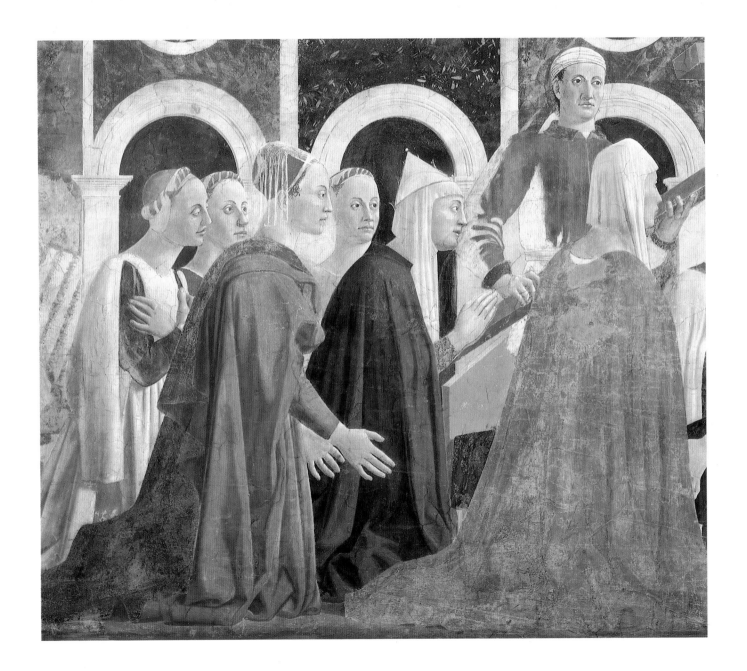

23. Helena and Her Ladies
detail of the Proofing of the Cross

Despite the fascination of the architecture, it is the human drama that commands attention. The looping arcades of the façade seem to hold the placid ecstasy of the broad-browed women in place. They gently tilt their heads in a subtle variety of angles, responding to the resurrection. These gestures, which seem so graceful and full of ease, were the result of arduous study on Piero's part. Much of his mathematical study was devoted to calculating the proportions of the skull in rotation (fig. 33). Under St. Helena's crown, for example, in a close-up view, one can see the stereometry he used in preparing the final execution.

Even more striking perhaps is the reciprocity of physiognomy and body language between Helena and her maids and the entourage of Sheba across the way. The identity of physical type expresses identity of spirit in those who experience miracles.

The separation between the urban space and the figural group reinforces the drama of the miracle. What is occurring in the foreground takes place not so much *in* the city as *for* the city, and the idealized architectural forms Piero invents clearly state that this city is a microcosm representing the modern Christian world.

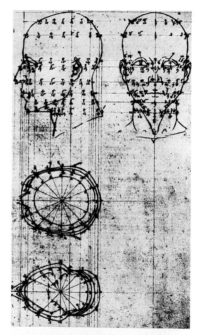

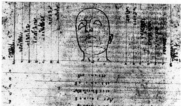

Fig. 33. Piero della Francesca, *Measured Heads.*

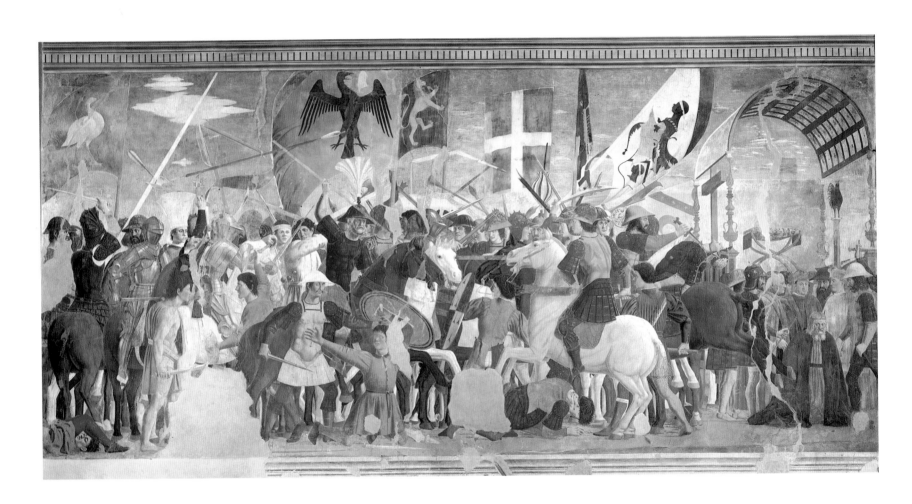

24. Battle of Heraclius; Death of Chosroes

The battle between the Byzantine Emperor Heraclius and Chosroes, king of the Sassanian Persians, took place in the summer of A.D. 628. It is one of the few historical events to be celebrated in the liturgy of the Western church. The description is read on the Feast of the Exaltation of the Cross, September 14, the day on which Heraclius returned a portion of the stolen relic to the church prepared by Constantine in Jerusalem.

By pairing Heraclius's battle on the lowest left tier with Constantine's on the opposite wall, Piero shows both are victories under the sign of the Cross. However, while equating their significance, he contrasted their form, changing traditional iconography in several ways. The Heraclius battle is depicted as a tumultuous fracas; warfare takes up three-quarters of the tier. The field is packed with officers, cavalry, foot soldiers, mercenaries, and slaves, all fighting for their lives. This time there is no rationalization, no preamble, no warning—just men at war. There are more legs than there are men; more horses' legs than horses; and again the mixture of classical and modern trappings. Spears fly through the air—some whole, some broken, some lying on the ground. The composition as a whole is sometimes criticized as confusing, yet Piero gives ample indication to distinguish the sides. More complex and numerous than in the *Victory of Constantine*, the flags and banners tell the tale.

Heroic and virtuous banners are on the left, facing right: the white goose on green (providence; vigilance; the legend of the geese that saved Rome from the Gauls); the black eagle on gold (the holy empire); the gold rampant lion on red (royal strength). In the center is the cross, white on red (faith and charity; and we have a central alignment of cross motifs on this wall too). Evil enemy banners are on the right, facing left: the yellow scorpion on black (symbol of the Jews), furled and hidden; two black Moors (head and bust) on white, torn in the center of the infidel; and finally a fallen banner, white with a thin blue chevron carrying three six-pointed planets on its arms and the hated crescent moon between. Most of these flags are standard fare in historical chronicles (see fig. 34); the scorpion is seen often in *Crucifixions*. But the way Piero has the designs face off makes the confrontation clear.

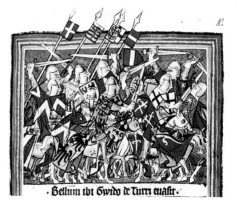

· Bellum ibi Gwido de Turri euasit ·

Fig. 34. *Heinrichs VII, Battle of Milan*, Koblenz Staatsarchiv.

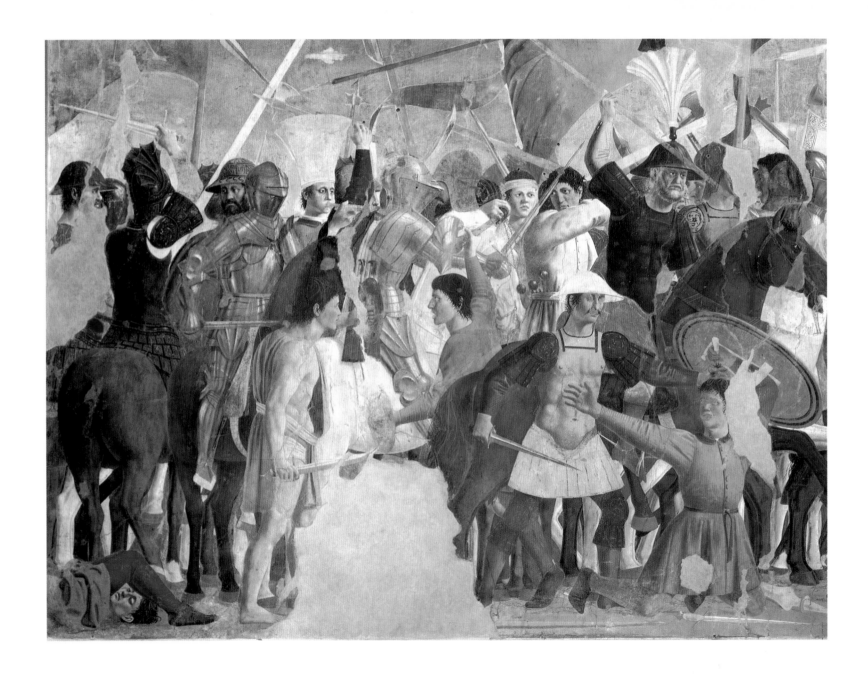

25. Knights and Trumpeter
detail of the Battle of Heraclius; Death of Chosroes

Compressed, as always, on the frontal plane, the battle-ground is a tightly woven fabric of impenetrable masses. Crisscrossing lances that fly through the air and lie across forms enhance the sense of abbreviation. Piero invented a kind of short-hand space in which forms are neither complete nor altogether readable. The parts that are visible are delineated in fulsome detail, as for example the trumpeter's face: distended cheeks and veined under the eyes, a gloriously shadowed neck with reflected light modeling the chin. But although it takes some time to realize it, it is impossible to locate the rest of his body. The trumpeter is on the same level as the adjacent horseman, yet there is no room for another horse. There

are, moreover, many such *disjecta membra*: single eyeballs (between two other forms), separate arms and legs, a severed head (in the lower left) under the bent legs of a partial body. In themselves, they are represented fully rounded, reflecting light and radiant in splendid garments, but they exist only as fragments. As a result, the composition lends itself to excerpting; an arbitrary group of figures like the one illustrated in the detail opposite makes a strong impact. It takes its power from the sheer physical force and frighteningly anonymous quality of the fighters. At the same time, the image has the quality of a modern, finished abstract design.

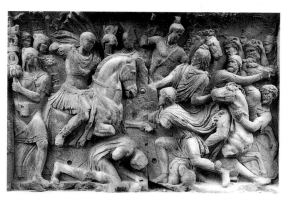

Fig. 35. Trajanic battle, Arch of Constantine, Rome. For a discussion of this image, see p. 85.

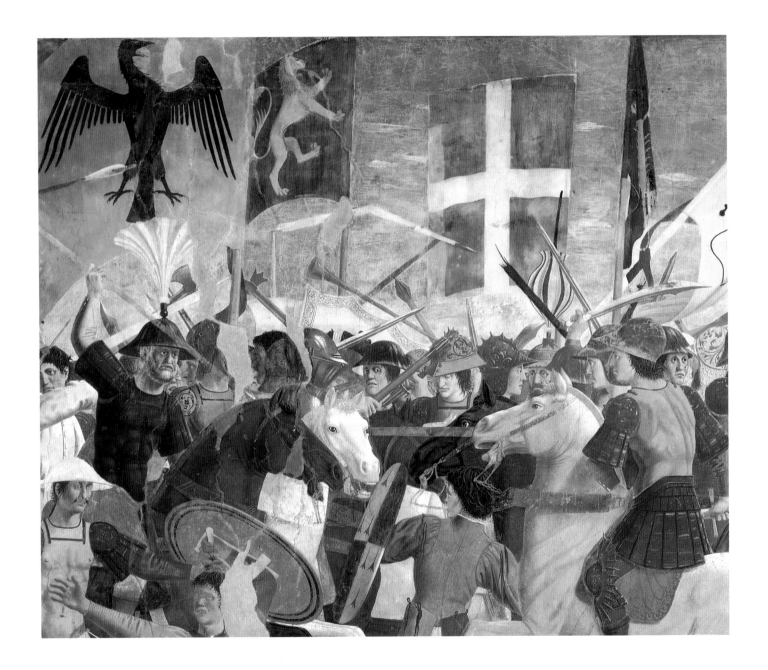

26. Battling General
detail of the Battle of Heraclius; Death of Chosroes

The gray-bearded horseman in a white-plumed helmet riding a chestnut stallion under the flag of the imperial eagle has the air of a commanding general. In his position at the center of the skirmish, and together with a partner on a white horse, he parallels Constantine and his mate on the opposite wall. The two pairs represent active and passive heroes. Constantine raises the cross in a static pose; this rider reins in his horse as he prepares to throw his lance. Constantine spills no Roman blood; Heraclius, who fought not brother Romans but a hated Persian foe, brings his enemies down by the sword.

In 1440 an impressive battle had taken place at Anghiari, just a few kilometers from Piero's native town. He thus may have had firsthand views of soldiers massing. He obviously knew a lot about the details of weaponry. We have seen his renditions of laminated armor with butterfly hinges at the knees in the latest Milanese style. His maces have the weight to crack a skull. One would not wish to get in the way of his three-balls-and-chains. But in spite of all the action, the soldiers are not in motion. They are the same contemplative, vaguely anguished creatures who always populate Piero's world. This operation alludes neither to orderly chivalric encounters nor to contemporary rough-and-tumble clashes. If there is any reference at all, it is to ancient monumental representations of historical events. The spear-throwing rider with fallen enemy below the horse's hooves and a foot soldier seen from the back depend appropriately on a classical relief on the triumphal arch erected by Constantine himself (fig. 35, p. 83), which Piero would have seen when he was in Rome. The pose of the rider, and most particularly his plumed helmet, follow the drawing of an equestrian statue with lance and feathered headpiece that existed in fifteenth-century Constantinople and may have represented Heraclius himself (fig. 36). The drawing was probably made by Ciriacus of

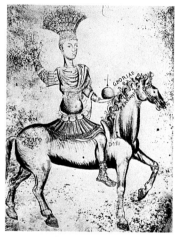

Fig. 36. Ciriacus (?), *Byzantine Rider*, drawing Ms. 35, fol. 144v, University Library, Budapest.

Ancona, who traveled to the East and on whose information Piero relied on other occasions. Such references give authenticity to the scene. However, there is that boy with his legs spread wide turned backward, holding a shield quartered in green and white with three red darts, at the very center of the foreground (see p. 82 for the entire figure). He wears a mauve jerkin with little laces at the shoulders, one green and one red pant leg over white *mutondini*, the two parts laced together with little bows. Piero never forgot his own world.

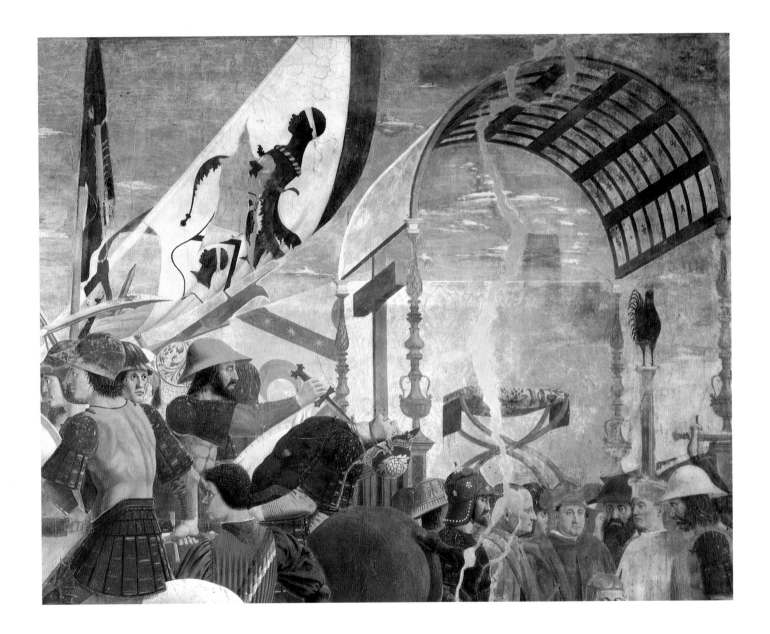

27. Battle and Throne Tabernacle
detail of the Battle of Heraclius; Death of Chosroes

Having omitted major scenes from this chapter of the legend, Piero combines the crime of Chosroes, his judgment, and the outcome of his trial into one image. Chosroes stole the Cross to have its power and set it up in the silver tower he used for his astrological mischief. In his madness he made an unholy trinity: he called the Cross the Son; he set a rooster on a column and called it the Holy Ghost; and he sat upon a throne and called himself God.

Piero encapsulates the sequence at the right end of the tier. To represent Chosroes's celestial pretensions, he devises an astonishing baldachin made up of eccentric parts. For support he uses urns and vase forms from carved grotesques, turning them into three dimensions. For the cosmic covering he makes a canopy of stars on a blue ground, all but transparent. The pictorial effects of this nonarchitectural architecture are treated with infinite suavity. On the platform underneath, a red damask cloth of honor hangs behind a throne in the form of a classical curule chair with a blue and white pineapple cushion, the kind reserved for potentates and judges. Because Chosroes is condemned, the throne is now empty. But still in place is the Cross itself, in oblique perspective on our left, and on our right, the rooster, imitating Peter's crowing cock, defiles the manifestation of the Holy Spirit.

One of the bloodiest events in the adjacent battle scene is a green-sleeved warrior stabbing an adversary in the neck. With the solemnity of a ritual sacrifice, the man sticks a dagger into the other man's throat. The victim, still wearing his dark red damask-patterned helmet, falls backward on his horse. As his arching back arrests in mid-fall, the position of his mouth coincides with the bottom of the Cross. Piero ends the battle here, as the foe of Christianity throws up the symbol of its survival.

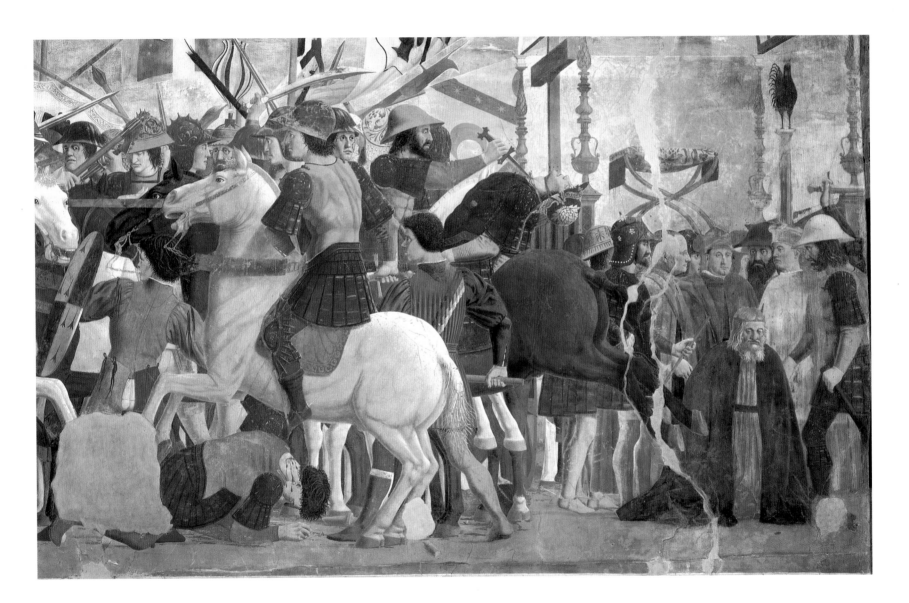

28. Execution of Chosroes
detail of the Battle of Heraclius; Death of Chosroes

Below the throne, the prisoner on his knees awaits the executioner's blade. In a consummate stroke of genius Piero visualizes the substance of his crime. Not only did Chosroes perpetrate the first great *sacra furta* (a term for the theft of a sacred Christian relic, which became something of an industry in the Middle Ages); he was a supreme blasphemer who called himself God Almighty. Piero tells this tale by making Chosroes, as he awaits decapitation, look like God. The face with its square forehead, large nose, and snaky white hair and beard is essentially the same as that of God the Father in the scene of the *Annunciation* directly to its right (pl. 12a).

The evil king is judged, moreover, not only by his seventh-century captors (the handsome young man in embossed parade armor, carrying a baton, who stands at the left is probably Heraclius's son), but by all the ages to come. Representing witnesses at the execution are three men in fifteenth-century garb. The one with a grizzled head, the one in a loosely wound turban, and the one wearing the red hat and robe of a well-to-do burgher are all surely members of the Bacci family, the Aretine patrons of the cycle. As the executioner raises his sword and a horse bucks, the Bacci, by their very presence, pledge to defend the Faith and keep all blasphemers at bay.

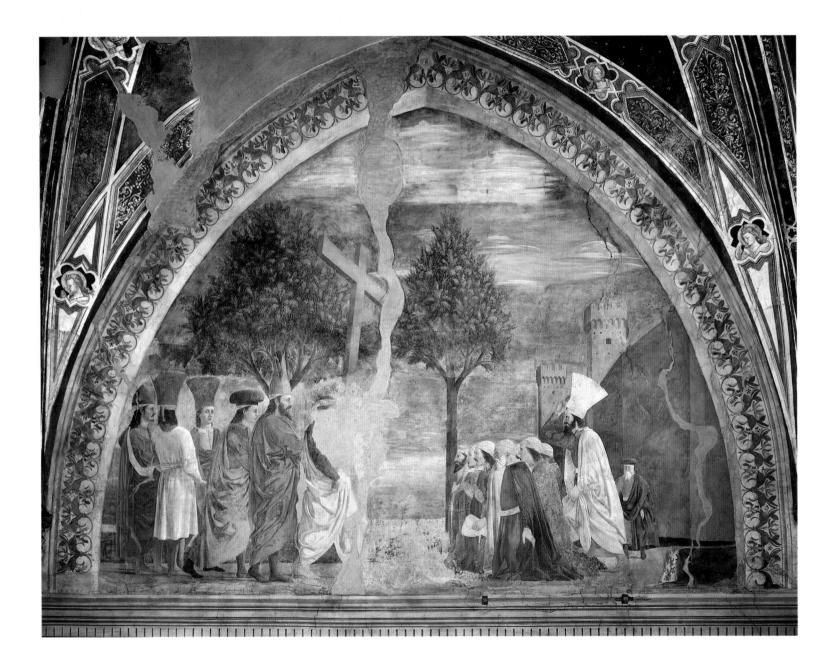

29. Exaltation of the Cross

In the final scene of the cycle, high in the left lunette, several events are again telescoped into one monoscenic composition. Agnolo Gaddi placed the scene, *St. Helena Brings the Cross to Jerusalem*, in an identical location on his left wall in Santa Croce (fig. 17). Helena moves from the left toward devotees who kneel outside the city gate. This scene was Gaddi's invention; it had not been seen before. A prophet in the upper right side of the painted frame holds a scroll reading "Roma," thus identifying Helena's action as bringing the relic to Rome, where indeed she founded the Basilica of Santa Croce in Gerusalemme.

With the structure and location of his scene, Piero pays tribute to Gaddi's innovation. And ideologically, the scenes are similar: in both it is the finder of the Cross who delivers it to the faithful. But Gaddi's scene speaks to the delivery of the relic, while Piero's speaks to its exaltation. As we have noted, Piero omits the episode of proud and haughty Heraclius, who tries to enter Jerusalem in procession with full military regalia. He is blocked from doing so by an angel and admonished by the Bishop Zachariah for not imitating Christ more closely. "Then Heraclius, taking off his ceremonial robes and his shoes and putting on a poor man's garment, easily went the rest of the way and placed the Cross on the same spot on Calvary from which it had been taken by the Persians" (Lesson 6 in the Breviary, reading for September 14).

Accompanied by four attendants (with their hats) and Bishop Zachariah, Heraclius brings the Cross to the center of the composition. By representing the episode as an isolated *adventus* scene, Piero transformed what had been by tradition a relatively anecdotal description of the miracle of Heraclius's entry into a solemn procession celebrating a major feast of the church: the Exaltation of the Cross. He made sure that the liturgical, historical, and spiritual importance of the scene would be immediately grasped by the worshiper by placing it closest to heaven, high in the lunette opposite the opening scene of the cycle.

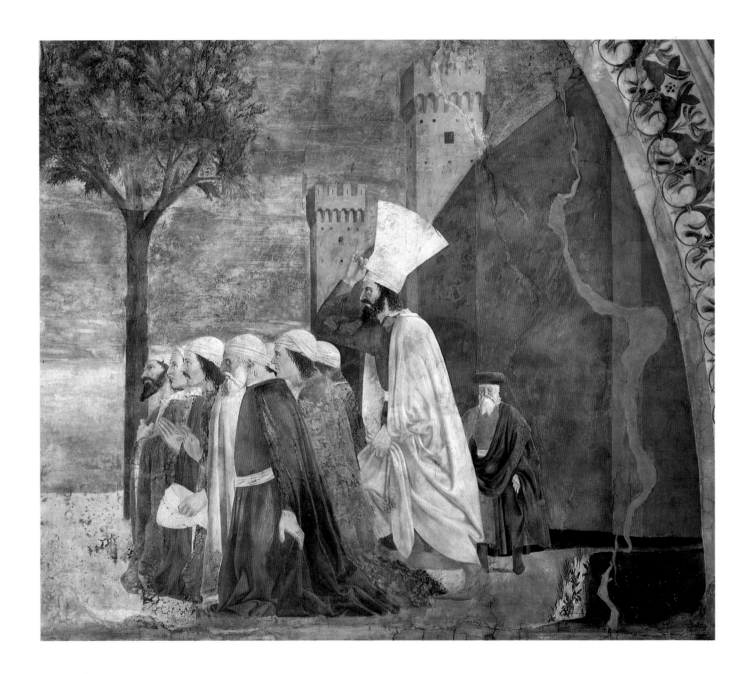

30. Heads of Jerusalemites
detail of the Exaltation of the Cross

In all other representations of the scene, the city gate constitutes a major focus. Piero, on the other hand, sets his scene far outside of the city, with no gate visible. This detail, along with the great roseate fortress walls casting shadows on the ground, help define how far away the figures are. Of the many Jerusalemites who come to extol the Cross, one doffs his tall white hat; an older gentleman still rushes along the road. Several who have already arrived kneel in concert. They all wear again the now familiar Byzantine/Near Eastern dress. Their white turbaned heads tilt and turn in celebratory effort; their sharply defined features express the beauty of their faith. Here again we see Piero's immaculate foreshortening skill in rotating and turning their forms. The perfection of their execution reflects the perfection of their devotion. Their joy is the very opposite of the lamentations of Adam's children. Their exaltation of the Cross is the happy conclusion of the scheme that began in death.

By matching the final scene of the cycle with that in the opening lunette, Piero performs the ultimate exorcism. In the words of the pre-Communion prayer of thanks known as the Preface of the Cross: "We should . . . give thanks unto Thee, O holy Lord . . . who didst establish the salvation of mankind on the tree of the cross; that whence death came, thence also life might arise again, and that he, who overcame by the tree also might be overcome."

31a. Prophet Ezekiel (?)

It is usual in fresco cycles to have Old Testament prophets appearing in various ancillary positions on the ceilings or archways. In the cycle by Agnolo Gaddi, for example, many prophets are positioned in the elaborately painted framework that surrounds each tier. These men are quite small in scale; they carry scrolls on which their many important messages are inscribed.

Piero's two figures of presumed prophets follow this tradition but also change it drastically. Instead of relegating them to a secondary position, he isolates them and places them prominently on the altar wall. They are not seated or half hidden in a niche, but stand upright and are grand in scale. They wear the same apostolic garb as many other figures in the cycle. They are not, however, specifically identified; only the one to the right holds a scroll but without an inscription. What distinguishes them more than any other characteristic is their youth, which is not usually associated with Old Testament prophets, who tend to be haggard and old. There is one striking case, however, where two quite pertinent prophets are represented as young and potent: on the jams of the main portal of the Cathedral of Modena, sculptured by Wilegelmo in the twelfth century (figs. 37

Fig. 37. Wilegelmo, *Ezekial*, Cathedral, central portal, door jam, Modena.

94

31b. Prophet Jeremiah (?)

and 38). One is labeled Jeremiah and the other, Ezekiel.

The figure on the left side of the window also turns to the right; he looks upward and lifts his right hand with fingers shaking. Rather than a scroll, he holds his green cloak across his red gown. His hair hangs in thick, snaky, blond locks. In his position above the *Annunciation*, with its elaborately carved closed door, the prophecy of Ezekiel is particularly pertinent: "Then said the Lord unto me: this gate shall be shut, it should not be opened, and no man shall enter by it; because the Lord of God of Israel hath entered in by it. . . . It is for the Prince" (Ezek. 44:1–4).

Piero's prophet standing on the right in a *contrapposto* pose also looking to the right, with a scroll in his left hand and dramatically lighted from behind (again in relation to the light coming from the real window), could well be Jeremiah. His prophecy is particularly pertinent as an assurance of the coming of salvation to the son of Adam: "Behold, the days come, saith the Lord, that I will raise unto David a righteous branch, and a King shall reign and prosper" (Jer. 23: 5–6). It is Jeremiah's words that the blond son of Adam hears (see page 40).

Fig. 38. Wilegelmo, *Jeremiah*, Cathedral, central portal, door jam, Modena.

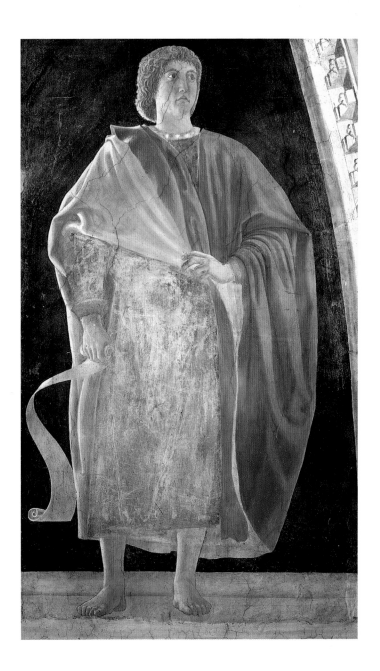

32a. Blind Cupid, left pilaster, top

32b. St. Michael Archangel, right pilaster, lower range

View of the left entrance pilaster showing the Blind Cupid (above) and St. Louis of Toulouse (below). A portion of the original crucifix, attributed to Margaritone d'Arezzo, can be seen on the right.

32a–i. Secondary Figures: Blind Cupid, Angels, Saints

Outside of the major fields of the fresco cycle, there are several non-narrative figures that modify the legend. At the top of the left entrance pilaster is a figure of Cupid (pl. 32a). He is represented naked and blindfolded; his bow hangs over his right shoulder, unused. Standing solidly in a *contrapposto* pose, Cupid holds a long arrow like a dart in his raised right hand. Surely this youthful warrior, symbolic of love in antiquity, is here meant to show the synchretistic value of the ancients, who knew so much and yet were blind to the one true God.

On the opposite pilaster, next to the fleeing Maxentius, is another winged warrior but from a different realm (pl. 32b). The angelic face, rosy cheeks, blond hair curling in front, in a pure white gown ruffled at the neck, is framed by symmetrical wings rising high at either side. The wings graduate in color from dark red through pink to almost white at the tops. This face is that of another of Piero's gorgeous youths, like Adam's son, like the blond young man in the *Flagellation*, like the angels in the *Baptism of Christ*. Here the only identification is what remains of a small round shield. He is thus identified as Michael, the archangel, whose portentous words began the legend with a promise. St. Michael Archangel, weigher of souls at the Last Judgment, warrior angel who drove out demons, because of these very features of his mission was a patron of St. Francis of Assisi, the worldly knight who gave up his fighting career to pursue the salvation of souls in the way of peace, love, and the wood of the Cross.

Other angelic heads appear in quattrefoils on the ribs of the vaults (pl. 32c and pl. 32d; see also fig. 20). One or two show the unmistakable care that Piero lavished on the emotional content of his figures. The expressions of some of these small faces show direct concern for the dramatic events they witness.

As we have seen, Bicci di Lorenzo was the painter in charge at the beginning of the commission. Before Piero came on the scene, Bicci had painted a Last Judgment on the "triumphal arch" above the entrance to the chapel. On the ceiling of the chapel, the same artist painted the four evangelists, traditional authorities for the gospel word. On the reredos, the undersurface of the entrance arch, full-length figures of the four fathers of the Western church (Gregory, Ambrose, Augustine [pl. 32e] and Jerome) were begun by Bicci, and later completed by Piero and his shop. Interestingly enough, St. Ambrose (pl. 32f), whose writings play such an important role in some of the ideological background of the cycle, is represented on the right side of the arch, just above the *Meeting of Sheba and Solomon* (see pl. 1b).

Around the double-light window, in the slanting reveals, one bust-length image remains; it was painted by a rather weak assistant of Piero (pl. 32h). The representation is of San Bernardino, an important Franciscan saint who died in 1444 and was already canonized in 1450. It is possible that more Franciscan saints, St. Anthony and St. Claire and St. Francis himself, were originally painted in other positions around the window. A fifth major saint of the order, St. Louis of Toulouse, by a different Piero follower, appears on the left entrance pilaster, next to the middle tier of the narrative, just below a figure of Cupid (pl. 32i).

32c. Angelic head in quattrefoil, on rib between right wall and right side of altar wall.

32d. Angelic head in quattrefoil, on rib between right wall and right side of altar wall.

32e. St. Augustine, on left side of reredos (underside of entrance arch)

32f. St. Ambrose, on right side of reredos (underside of entrance arch)

32g. St. Peter Martyr, on left entrance pilaster next to the lowest narrative pier.

32h. San Bernardino of Siena, in slanting reveals, left side of double-light window

The last image we mention is that of a saint not of the Franciscan but of the Dominican order: St. Peter Martyr, who is shown on the left entrance pilaster next to the lowest narrative pier (p. 32g). This St. Peter was a great preacher who promulgated above all else the Credo. Death came to him at the hands of a heretic, as he continued to recite this symbol of faith. He is identified here by his black-and-white habit, and by the dagger that his assailant plunged in his shoulder when he did not die fast enough from his head wounds. The beautifully modeled, serious face is thus the perfect counterpart and antidote to the heretical King Chosroes, executed by the sword, at the opposite end of the same register.

32i. St. Louis of Toulouse, left entrance pilaster, under Blind Cupid

LIST OF FIGURES

Fig. 1 (p. 7) Piero della Francesca, *Flagellation of Christ*, c. 1458-60, tempera on wood, 58 x 112 cms., Galleria Nazionale delle Marche, Palazzo Ducale, Urbino.

Fig. 2 (p. 9) Giotto?, *Exorcism of the Demons from Arezzo*, ca. 1285-95, fresco, San Francesco, Upper Church, Assisi.

Fig. 3 (p. 14) *Stavelot Triptych*, 1130-58, copper gilt, enamel, jewels, 484 x 660 mm., Pierpont Morgan Library, New York.

Fig. 4 (p. 16) Diagram of narratives, the Legend of the True Cross cycle, chancel, San Francesco, Arezzo. Diagram by Susanne Philippson Ćućić.

Fig. 5 (p. 17) Diagram, disposition of the cycle of the True Cross by Agnolo Gaddi, Santa Croce, chancel, Florence. Diagram by Susanne Philippson Ćućić.

Fig. 6 (p. 18) Agnolo Gaddi, *Story of Adam*, 1388-93, fresco, Santa Croce, chancel, right wall lunette, Florence.

Fig. 7 (p. 19) Agnolo Gaddi, *Story of Sheba and Solomon*, 1388-93, fresco, Santa Croce, chancel, right wall, second tier, Florence.

Fig. 8 (p. 20) Agnolo Gaddi, *Dredging of the Probatic Pool and Fabrication of the Cross*, 1388-93, fresco, chancel, right wall, third tier, Florence.

Fig. 9a (p. 22) Pol de Limbourg?, *Medal of Constantine*, ca. 1406, bronze, diam. .095, National Gallery of Art, Washington, D.C., Samuel H. Kress Collection 1957.14.1119. (SC)

Fig. 9b (p. 22) Pol de Limbourg?, *Medal of Heraclius*, ca. 1406, bronze, diam. .098, National Gallery of Art, Washington, D.C., Samuel Il. Kress Collection 1957.14.1120. (SC)

Fig. 10 (p. 22) Miguel Alcaniz, *Retablo Santa Cruz*, ca. 1410, tempera on wood, Museo Provincial del Bella Artes de San Carlos, Valencia.

Fig. 11 (p. 23) Agnolo Gaddi, *Chosroes Adored; Dream of Heraclius; Battle of Heraclius*, 1388-93, fresco, Santa Croce, chancel, left wall, third tier, Florence.

Fig. 12 (p. 23) Piero della Francesca, head of a guard from *Constantine's Vision* (left) and horse's head from *Victory of Constantine* (right), 1452-66, fresco, right corner, third tier, San Francesco, Arezzo.

Fig. 13 (p. 23) *Battle of Constantine*, detail of *Stavelot Triptych*, 1130-58, copper gilt, enamel, jewels, dia. 108 mm, Pierpont Morgan Library, New York.

Fig. 14 (p. 24) Agnolo Gaddi, *Finding and Proofing of the Cross*, 1388-93, fresco, Santa Croce, chancel, right wall, fourth tier, Florence.

Fig. 15 (p. 25) Michele di Mattteo, *St. Helena Altarpiece*, predella, detail, ca. 1427, tempera on wood, Accademia, Venice. Photo: Cameraphoto/Art Resource, NY.

Fig. 16 (p. 26) Agnolo Gaddi, *St. Helena Brings the Cross to Jerusalem*, 1388-93, fresco, Santa Croce, chancel, left wall lunette, Florence.

Fig. 17 (p. 27) Agnolo Gaddi, *Chosroes Steals the Cross*, 1388-93, fresco, Santa Croce, chancel, left wall, second tier, Florence.

Fig. 18 (p. 27) Agnolo Gaddi, *Chosroes Beheaded; Heraclius Stopped by an Angel; Exaltation of the Cross*, 1388-93, fresco, Santa Croce, chancel, left wall, fourth tier, Florence.

Figs. 19a-c (p. 28) Patterns of narrative disposition. Diagrams by Susanne Philippson Ćućić.

Fig. 20 (p. 40) Rib between right wall and right side of altar wall showing the relationship between *Two Boys* in the *Story of Adam* and the *Prophet Jeremiah* (?), Legend of the True Cross cycle, San Francesco, Arezzo.

Fig. 21 (p. 50) Boccaccio, "The Story of Andreuccio," *Decamerone*, 1492, woodcut, Stampa di Gregori, Venice. Photo: courtesy of Vittore Branca.

Fig. 22 (p. 55) *Habakkuk Carried by an Angel*, wooden doors, Santa Sabina, Rome. Photo: Alinari/Art Resource, NY.

Fig. 23 (p. 62) Photograph, demonstration of the position of the angel's hand in *Constantine's Vision*. Photo: author.

Fig. 24 (p. 64) *Crucifixion of Christ with the Dead Adam*, Ottonian ivory relief, H. 5, W. 3½ in., Metropolitan Museum of Art, New York, Gift of J. Pierpont Morgan, 1917. (17.190.44).

Fig. 25 (p. 64) Masolino, *Death of St. Ambrose*, ca. 1428-31, fresco, San Clemente, Sacrament Chapel, Rome.

Fig. 26 (p. 66) Antonio Pisanello, corner view, *Chivalric Fresco*, ca. 1447-48, fresco, Salone, Palazzo Ducale, Mantua.

Fig. 27 (p. 66) Johann Antoine Ramboux, watercolor copy of Piero's *Victory of Constantine*, ca. 1820, Graphische Sammlung, Dusseldorf.

Fig. 28 (p. 68) *Heinrichs VII, Battle at the Milvian Bridge*, ca. 1350, manuscript illumination, Koblenz Stattsarchiv IC, no. 1, fol. 19 (after Heyen).

Fig. 29 (p. 70) Antonio Pisanello, *Medal of John VII Paleologus*, ca. 1439, bronze, dia. 104 mm., Louvre, Cabinet des Medailles, Paris. Photo © R.M.N.

LIST OF PLATES

Fig. 30 (p. 70) Spinello Aretino, detail, *Totila's Guard*, ca. 1390, fresco, San Miniato, sacristy, Florence.

Fig. 31 (p. 75) Paul Cezanne, *View of Gardanne*, ca. 1885, oil on canvas, 80 x 64.2 cm., Metropolitan Museum of Art, New York. Gift of Dr. and Mrs. Franz H. Hirschland, 1957 (57.181).

Fig. 32 (p. 77) Antonio Filarete, *Arrival of the Greeks*, bronze relief, doors of St. Peter's, Vatican.

Fig. 33 (p. 79) Piero della Francesca, *Measured Heads*, two illustrations from Piero's treatise *Prospective pingendi*, manuscript in Biblioteca Ambrosiana, Milan [after Pierluigi De Vecchi, *L'opera completa di Piero della Francesca*, (Classici dell'arte, Rizzoli, Milan, 1967, p. 110)].

Fig. 34 (p. 81) *Heinrichs VII, Battle of Milan*, ca. 1350, Koblenz Straatsarchiv IC, co. l, fol. 10b.

Fig. 35 (p. 83) Trajanic Battle, second century, stone relief, Arch of Constantine, Rome. Photo: Alinari/Art Resource, NY.

Fig. 36 (p. 85) Ciriacus (?), *Byzantine Rider*, ca. 1435–40, drawing, Ms. 35, fol. 144v, University Library, Budapest.

Fig. 37 (p. 94) Wilegelmo, *Ezekiel*, ca. 1150, stone relief, Cathedral, central portal, door jam, Modena.

Fig. 38 (p. 95) Wilegelmo, *Jeremiah*, ca. 1150, stone relief, Cathedral, central portal, door jam, Modena.

	Plate
Interior, Church of San Francesco, Arezzo	1a
The Legend of the True Cross cycle	1b
Chancel of the Church (left side)	1c
Chancel of the Church (right side)	1d
Story of Adam	2
Death of Adam (detail)	3
Two Boys (detail)	4
Story of Sheba and Solomon	5
Sheba's Grooms (detail)	6
Recognition of the Holy Wood (detail)	7
Meeting of Sheba and Solomon (detail)	8
Raising of Judas from the Well	9a
Judas Pulled Up by the Hair (detail)	11
Burial of the Wood	9b
Workmen (detail)	10
Annunciation	12a
God the Father (detail)	13
The Virgin and Angel (detail)	14
Constantine's Vision	12b
Angel of Constantine's Vision (detail)	15
Soldiers and Sleeping Constantine (detail)	16
Victory of Constantine	17
Flags and Lances (detail)	18
Head of Constantine and Two Horses (detail)	19

	Plate
Invention of the Cross (Finding and Proofing of the Cross)	20
The City of Arezzo (detail)	21
Proofing of the Cross (detail)	22
Helena and Her Ladies (detail)	23
Battle of Heraclius; Death of Chosroes	24
Knights and Trumpeter (detail)	25
Battling General (detail)	26
Battle and Throne Tabernacle (detail)	27
Execution of Chosroes (detail)	28
Exaltation of the Cross	29
Heads of Jerusalemites (detail)	30
Prophet Ezekiel (?)	31a
Prophet Jeremiah (?)	31b
Blind Cupid	32a
St. Michael Archangel	32b
Angelic heads	32c, 32d
St. Augustine	32e
St. Ambrose	32f
St. Peter Martyr	32g
San Bernardino of Siena	32h
St. Louis of Toulouse	32i

SELECTED BIBLIOGRAPHY

Alpatoff, Michel. "The Parallelism of Giotto's Paduan Frescoes." *Art Bulletin* 29 (1947): 149–54.

Ashton, John. *The Legendary History of the Cross*. London, 1887.

Babelon, Jean. "Jean Paleologus et Ponce Pilate." *Gazette des Beaux-Arts* 4, ser. 6 (1930): 365–75.

Battisti, Eugenio. *Piero della Francesca*. Milan, 1971; Milan, 1992.

Bertelli, Carlo. *Piero della Francesca*. Milan, 1991; London, 1992.

Biondo, Flavio. *Roma Triumphans*. 1459. Reprint. Basel, 1559.

Blume, Dieter. *Wandmalerei als Ordenspropaganda, Bildprogramme im Chorbereich franziskanischer Konvente Italiens bis zur Mitte des 14. Jahrhunderts.* Heidelberger Kunstgeschichtliche 17. Worms, 1983.

Bonaventura, St. *The Disciple and the Master: St. Bonaventure's Sermons on St. Francis of Assisi.* Translated by Eric Doyle. Chicago, 1983.

Borsook, Eve. *The Mural Painters of Tuscany, from Cimabue to Andrea del Sarto.* Oxford, 1960; Oxford, 1980.

———. Review of Ginzburg (see below). *Burlington Magazine* 125 (1983): 163–64.

Branca, Vittore. *Boccaccio medievale*. Florence, 1981.

Brucker, Gene. *The Civic World of Early Renaissance Florence*. Princeton, 1977.

Burali, Jacopo. *Vite de Vescovi Aretini, 336–1638.* Arezzo, 1638.

Calvesi, Maurizio. "La Flagellazione nel quadro storico del Convegno di Mantova e dei progetti di Mattia Corvino." In *Monarca della Pittura: Piero and His Legacy.* Papers of the 1992 Colloquium, Washington, D.C. Forthcoming.

Clark, Kenneth. *Piero della Francesca*. London, 1951; London, 1969.

Cole, Bruce. *Agnolo Gaddi*. Oxford, 1977.

Curschman, Michael. "Constantine-Heraclius: German Texts and Picture Cycles." In *Monarca della Pittura: Piero and His Legacy.* Papers of the 1992 Colloquium, Washington, D.C. Forthcoming.

Francis, St., of Assisi. *Writings and Early Biographies, English Omnibus of the Sources for the Life of St. Francis.* Edited by Marion A. Habig. Chicago, 1973.

Gilbert, Creighton. *Change in Piero della Francesca*. Locust Valley, N.Y., 1968.

Ginzburg, Carlo. *Indagine su Piero*. Turin, 1981. English edition. *The Enigma of Piero. Piero della Francesca: The Baptism, the Arezzo Cycle, the Flagellation.* London, 1985.

Hendy, Philip. *Piero della Francesca and the Early Renaissance*. London, 1968.

Horace (Quintus Horatius Flaccus). *Ars Poetica.* Edited by Charles D. N. Costa. London and Boston, 1973.

Jacobus de Voragine. *The Golden Legend.* Translated and adapted by Granger Ryan and Helmut Ripperger. New York, 1961.

Lavin, Marilyn Aronberg. *Piero della Francesca*. New York, 1992.

———. *Piero della Francesca: The Flagellation of Christ.* Chicago, 1972; Chicago, 1990.

———. *The Place of Narrative: Mural Decoration in Italian Churches, 421–1600 A.D.* Chicago, 1990.

———. "Researching Visual Images with Computer Graphics." *Computers and the History of Art* 2 (1992): 1–5.

Lightbown, Ronald. *Piero della Francesca*. Oxford, 1992.

Longhi, Roberto. *Piero della Francesca*. Milan, 1927; Milan, 1963.

Paolucci, Antonio *Piero della Francesca*. Florence, 1989.

Salmi, Mario. *La Pittura di Piero della Francesca*. Novarra, 1979.

GLOSSARY OF FRESCO TERMS

Affresco (from the word for "fresh"; in English, "fresco"). Painting on freshly laid plaster with pigments dissolved in water. As plaster and paint dry together, they become united chemically. Known as "true" fresco (or "buon fresco"), but frequently used in combination with "secco" (see below) details, this technique was in general use for mural painting in Italy from the late thirteenth century on.

Arriccio (literally "rough"). The first layer of plaster spread on the masonry in preparation for painting; the "sinopia" (see below) is executed on this surface. It was purposely left rough so that the top layer (see "intonaco") would adhere to it more firmly.

Cartone (from the word for "heavy paper"; in English, "cartoon"). An enlarged version of the main lines of the final composition done on paper or cloth, sometimes, but not always, equal in size to the area to be painted. The cartoon was used to transfer the design to the wall; it could be divided in several sections for the creation of one large image. The cartoon was laid against the wall over the final layer of fresh plaster, so that outlines of the forms could be either incised with a stylus or transferred by "pouncing" (see "spolvero"). In either case, the outlines were used as guides for the artist to paint. The procedure was in common use by the second half of the fifteenth century, although it had been developed earlier.

Giornata (from the word for "day"). The patch of "intonaco" to be painted "daily," not necessarily in one day. The artist decided in advance the size of the surface he would paint and laid on top of the "arriccio" or rough plaster only the amount of fresh "intonaco" or fine plaster needed for his work. The joinings usually are discernible upon a close examination of the painted surface, and they disclose the order in which the patches were painted because each successive patch slightly overlaps the preceding one.

Intonaco (literally "whitewash," or fine plaster). The final smooth layer of plaster on which painting with colors was carried out. Made from lime, fine sand, and marble dust and laid in sections (see "giornata").

Pounce, pouncing. Fine powder, usually pulverized charcoal, dusted over a stencil to transfer a design to an underlying surface.

Secco (literally "dry"). Painting on plaster that has already dried. The colors are mixed with an adhesive or binder to attach the color to the surface to be painted. The binding medium may be made from various substances, such as tempera. "Tempera" (pigment and animal or vegetable glue) or less often "tempera grassa" (pigment and egg) was commonly used to complete a composition already painted in fresco. Because the pigment and the dry wall surface do not become thoroughly united, as they do in true fresco, mural paintings done in tempera (or "a secco") tend to deteriorate and flake off the walls more rapidly.

Sinopia Originally a red ochre named after Sinope, a town on the Black Sea that was well known for its red pigments. In fresco technique the term was used for the final preparatory drawing on the "arriccio," which was normally executed in red ochre.

Spolvero (from the word for "dust"). An early method (see "cartone") of transferring the artist's drawing onto the "intonaco." After drawings as large as the frescoes were made on paper, their outlines were pricked, and the paper was cut into pieces the size of each day's work. After the day's patch of "intonaco" was laid, the corresponding drawing was placed over it and "dusted" with a cloth sack filled with charcoal powder, some of which passed through the tiny punctured holes to mark the design on the fresh "intonaco."